PRAIRIESCAPES

VISIONS OF ILLINOIS

A series of publications portraying the rich heritage of the state
through historical and contemporary works of photography and art

Prairiescapes
Photographs by Larry Kanfer

Nelson Algren's Chicago
Photographs by Art Shay

Stopping By: Portraits from Small Towns
Photographs by Raymond Bial

Changing Chicago:
A Photodocumentary

Chicago and Downstate: Illinois as Seen by the Farm Security
Administration Photographers, 1936–1943
Edited by Robert L. Reid and Larry A. Viskochil

The Many Faces of Hull-House: The Photographs of Wallace Kirkland
Edited by Mary Ann Johnson

Beneath an Open Sky
Panoramic Photographs by Gary Irving

Billy Morrow Jackson: Interpretations of Time and Light
Howard E. Wooden

The Carnegie Library in Illinois
Raymond Bial and Linda LaPuma Bial

Spirited Visions: Portraits of Chicago Artists
Patty Carroll and James Yood

On Second Glance
Midwest Photographs by Larry Kanfer

PRAIRIESCAPES

PHOTOGRAPHS BY LARRY KANFER

WITH A FOREWORD BY WALTER L. CREESE

UNIVERSITY OF ILLINOIS PRESS · URBANA AND CHICAGO

Library of Congress Cataloging-in-Publication Data

Kanfer, Larry, 1956–
Prairiescapes : photographs.

1. Photography—Illinois—Landscapes. 2. Prairies—
Illinois—Pictorial works. I. Title.
TR660.5.K36 1987 779′.36′0924 87-14807
ISBN 0-252-01482-0

*For Mom and Dad, who provided the perspective
by which I view the world*

FOREWORD

Artists can help us see things in our environment that we might otherwise miss; they can make commonplace sites seem out of the ordinary. Larry Kanfer, through his photographs, does just that, bringing new meaning and dignity to the act of residing in Central Illinois. He joins a group of distinguished artists—perhaps another prairie school in the making?—who have manifested a continuing interest in the prairie, as viewed through the banquet camera of the late Arthur Sinsabaugh, in the exquisitely detailed paintings of Billy Morrow Jackson, and in the rich scenography of Harry Breen. Yet even with the influx of new talent, it is unlikely that the conundrum of the midwestern landscape, its "Rubik's Cube" appearance, will ever be fully revealed.

The Grand Prairie represents what machinery can do when applied to nature on an enormous scale. This has been a recurrent national challenge since the first great textile mills and model manufacturing towns were built, beginning in 1822, beside such power sources as the waterfalls at Lowell and Lawrence, Massachusetts, signaling the onset of major spatial occupations from the Industrial Revolution. A decade or two later, Central Illinois undertook an agrarian response, which we see around us now, to that inquiry first put forth on the East Coast. The question of how technology qualifies the landscape was asked again in 1933, through the Tennessee Valley Authority, covering 41,000 square miles and terminating at the southern border of Illinois, on the Ohio River.

In moving about Illinois, as Kanfer's photographs do, we become simultaneously aware of the directions north, south, east, and west. Kinesthetically, our location can easily be mistaken for the center of the state, and even of the nation. This sense of squaring off in a central place is enhanced by the outline of grid and supergrid that has been imposed on farming since the 1830s. The impression is reinforced by the country roads that run straight between the fields, with farmhouses along them at regular intervals. We cannot shake the feeling that another town or village is bound to come up after a number of farmsteads have been counted and passed.

This continuous order, executed in four directions, is visually confirmed in *Prairiescapes* by objects in line and on edge, such as the by-now vanishing hedge of Osage orange trees, the barbed wire fence, the snow fence, wires carried on poles, and the slightly elevated railroad tracks on which Kanfer captures a string of freight cars with their luminous white signs. More substantial acknowledgment of such linear logic lies in the bottomlands, such as those of the Embarrass, Kaskaskia, and Sangamon rivers, with their banks held up by oak, maple, and hickory, and the redbud that blooms earliest, paralleled by the elevated and exposed glacial moraines that move south, each ridge barely in sight of another across the open fields.

Larry Kanfer is partial to what may be described as "singularities": the house or barn standing alone; the mercury vapor lamp atop a twenty-four-foot pole in a farmyard, appearing as an inexplicable blue sapphire on a hillock at twilight; the frozen pool of water, one to a field; a one-room schoolhouse, the first legal requirement before a settlement could be established; the rural mailbox on a roadside post; the solitary cottonwood a car can overtake in minutes, a tractor in a lot longer. His photographs occasionally elicit a double-take, as with the red stop sign revealed suddenly, at the end of a dark road by a car's headlights; the snow fence with ILL stenciled in white, twice along its stretch, like the letters on an athlete's sweater; the spectroscopic rainbow seen at its zenith, several instants after the eye catches handsome rows of golden wheat rooted to the earth; the partial moon hovering in a cloudless sky, like half of a white balloon; the green novitiate heads of corn plants—that by July will have transformed themselves into an aggregate of orderly stalks—just perceptible in the dark brown field as winter turns to spring.

There is a notable absence of monumental or hierarchical structures on the prairie, and Kanfer purposely omits the two types that ordinarily gather and punctuate the distance—the grain elevator and the country church. He mostly leaves people out of the frame, too. And there is no need to hunt for recollections of the buildings of a past aristocracy, as there would be in the South or the Upper Midwest. Here, all is even, egalitarian, and politically and economically democratic, except perhaps among the Amish community on the southern edge of the region, which Kanfer signifies with an enclosed, horse-drawn buggy, having no association with machinery. Tattered coveralls wave on a clothesline like a medieval banner, except here they are gray and monochromatic. The rare frame of living blossoms is of the cornflower, very humble and well-nourished in roadside ditches, a brighter blue than the sky when the sun rises which later fades to a white-pink, only to close as the day ends. And he especially appreciates the simple shine of new grasses in the spring.

Larry Kanfer seems to favor the more generalized atmosphere of the quiescent autumn when, despite all the bustle of the behemoth harvesting machines, a wonderful serenity and glow settle upon the fields. Yet he characteristically wants us to be aware of the many possible exceptions to this universal mood. The most lowering of clouds can appear in the sky, as can the most churning and truculent of thunderstorms. Sunsets can be sumptuous in their drapery, as in the lurid yellow-orange-red that paints the day after a storm has just lowered its clouds to drench the earth and summon up its own narcissistic image.

Many of these photographs juxtapose field and sky, which makes the exceptions all the more vivid: the spectator in a snowstorm; fog that blurs out both the upper and lower registers, reconciling any awkward planes of farm buildings by casting them as quiet silhouettes; the blizzard that twists and dwarfs trees and even scours ubiquitous white paint off houses and barns. Here, we are momentarily relieved of the obligation to salute the horizon. The black-and-white photographs at the end of the book, which resemble pencil sketches, persuade us that the prairie may be a mirage after all, a figment of our collective imagination. Color yields to pure light, urgency to calm, texture to planarity, the ordinary to the unique.

All of us can live more wholesomely on the prairie by acknowledging what Larry Kanfer tells us throughout his pictorial essay—that the openness and spread of the earth create an indigenous loneliness for the smaller single object and person; that the openness and light of the prairie skies bring forth their own mysteries.

Walter L. Creese
Champaign, Illinois

INTRODUCTION

Growing up in Portland, Oregon, amid a stunning panorama of mountains, lakes, and forests, I wondered what it would be like to live someplace completely different . . . someplace that was flat, where colors and dimensions were not totally overwhelming. Now, living in the heart of the prairie, I have my answer.

The prairie landscape is not beautiful in the traditional sense; certainly there are no soaring mountains or rugged coastlines. But there is a gentle, subtle beauty apparent to those who take the time to discover it; to those who make the effort to look, and then look again. My goal as an interpretive artist is to challenge those who dismiss the Midwest as being flat and nondescript and help them discover the colors, textures, and lines that together dramatize the prairie. I am convinced that the sudden thrill of this "ah-hah" experience of discovery makes it time well spent.

My intense interest in the midwestern landscape became more focused while I was an architecture student at the University of Illinois. Through interpretive photography I was able to give tangible meaning to abstract architectural concepts of composition and form. The thrill of watching these concepts come to life, coupled with the pleasure of exploring the countryside and its inhabitants, led to my decision to pursue a career in photography. Today, I continue to rely heavily on my design background, using it to create images that capture the essence of the Heartland.

In composing the images in *Prairiescapes* I chose strong elements that would evoke an immediate response. Each composition also includes enough supporting detail to allow you to discover something new each time you see the image; indeed, I want you to feel compelled to examine the scene again and again.

When photographing the Midwest, I rely on the colors, textures, lines, seasons, and moods that make the region special. For example, in *Midwest Horizon* (1985) a certain mood is established by the comforting sight of a farmstead nestled against the pastels of a winter sunset. Even if you are not intimately acquainted with life in the country, you can still relish the serenity of the scene and imagine the stir of activity within the buildings that serrate the horizon.

Bare Trees (1984), another mood piece, is more pensive and intimate. In contrast to the warm colors and open spaces of *Midwest Horizon*, here the surrounding fog creates a feeling of isolation, as if time has stopped within the confines of the frame; in fact, without the muted colors and sense of closeness created by the fog, the entire feeling of the photograph would change. *Backyard Sunrise* (1985) presents the interplay of texture and color: as light strikes the various planes, a strong foreground and background are created and the image appears to be three-dimensional.

One of my most well-received compositions, in the traditional sense, is *University and Prospect* (1981), with its focal point in the bottom left third of the image, in keeping with classic design principles. Your eyes are drawn in a circular pattern by layers of tree limbs which point from left to right. The line continues, as the fence runs from right to left, pulling you back to the focal point. Of secondary importance is the sense of mystery associated with the foggy lightness at the end of the walkway; the resolution, or answer, to what lies at the end of the path is denied you. It is the combination of these factors that makes the image interesting.

Often, I employ several of these techniques simultaneously, seeking a feeling or mood that I call "concept." The concept of *Loner* (1980) is abandonment and isolation. To share this feeling with you, I centered the house, lending an intense static quality to the picture. The bleak colors and textures of peeling paint, untilled fields, and a naked tree serve to reinforce the lonely and abandoned mood of the scene.

Many times when I recall the process of photographing a particular image I realize that the meaning of the photograph has changed with

the passing of time. Obviously, the image itself has not changed, but my perception has been altered to allow for a varying interpretation of the landscape. These perceptual changes are a reflection of personal and professional life experiences that continue to influence my work.

Those changes in style that are reflected in my work, over time, have not been so much in subject or composition but rather in a refinement and narrowing of focus. The rough yet painterly qualities of *Prairie Cabin* (1984), for example, are further refined in *Cupboard Door* (1985) and *Flower Basket* (1985).

The longer I study the intracacies of the prairie landscape, the more I appreciate the work of painters and sculptors who strive to interpret those same subtle nuances in the macroenvironment. Our tools may be different, but our interpretations can be strikingly similar. People are, after all, more alike than not, and the foreboding clouds billowing forward in *Tornado Watch* (1979) demand equal respect from the artist, the farmer, and the financial analyst.

I take pleasure in offering to each of you a tiny glimpse of the endless beauty that surrounds us on the prairie.

Larry Kanfer
Champaign, Illinois

PRAIRIESCAPES

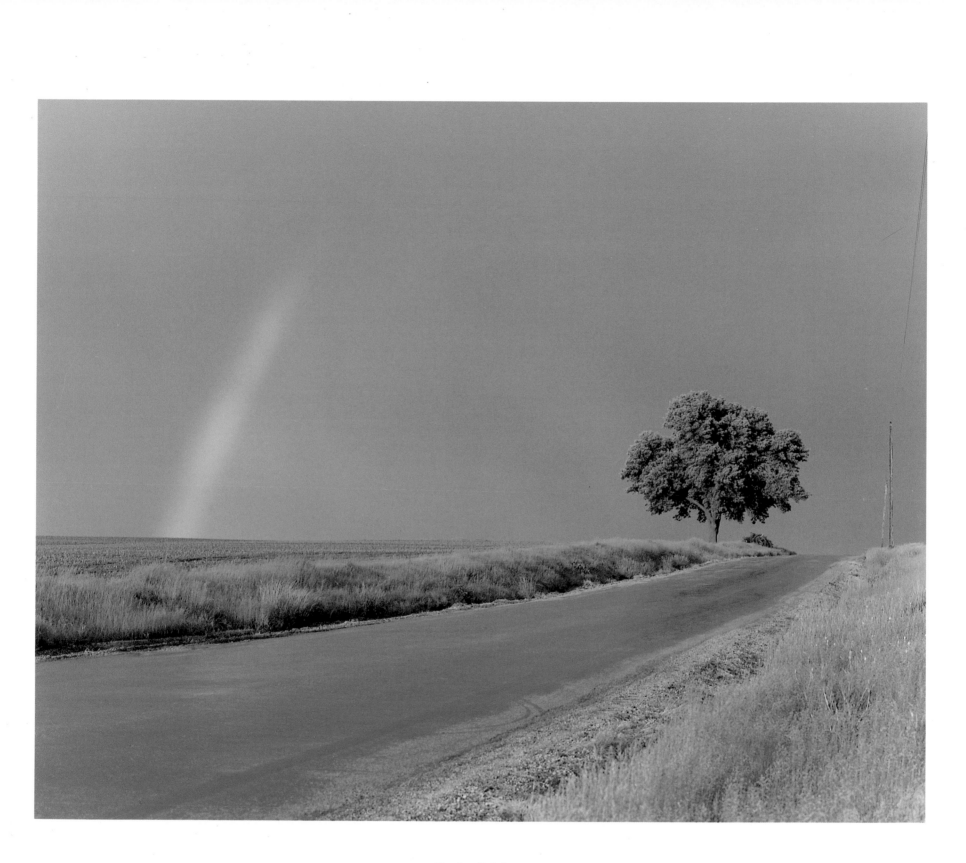

Gordon Rainbow

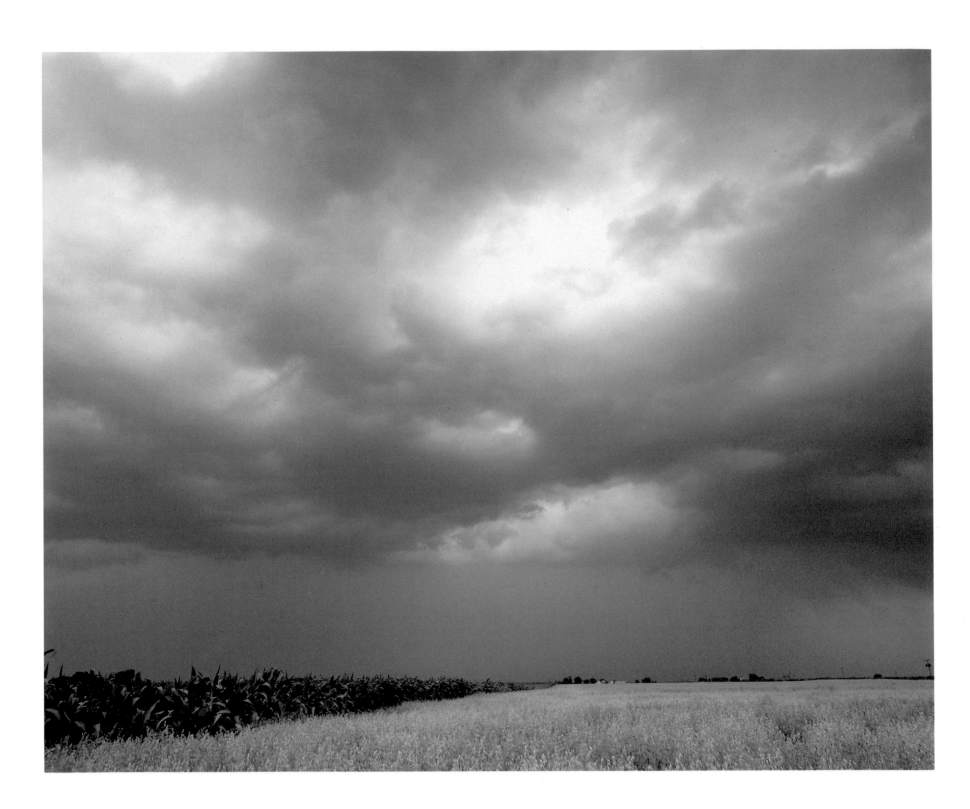

Midseason Tempest

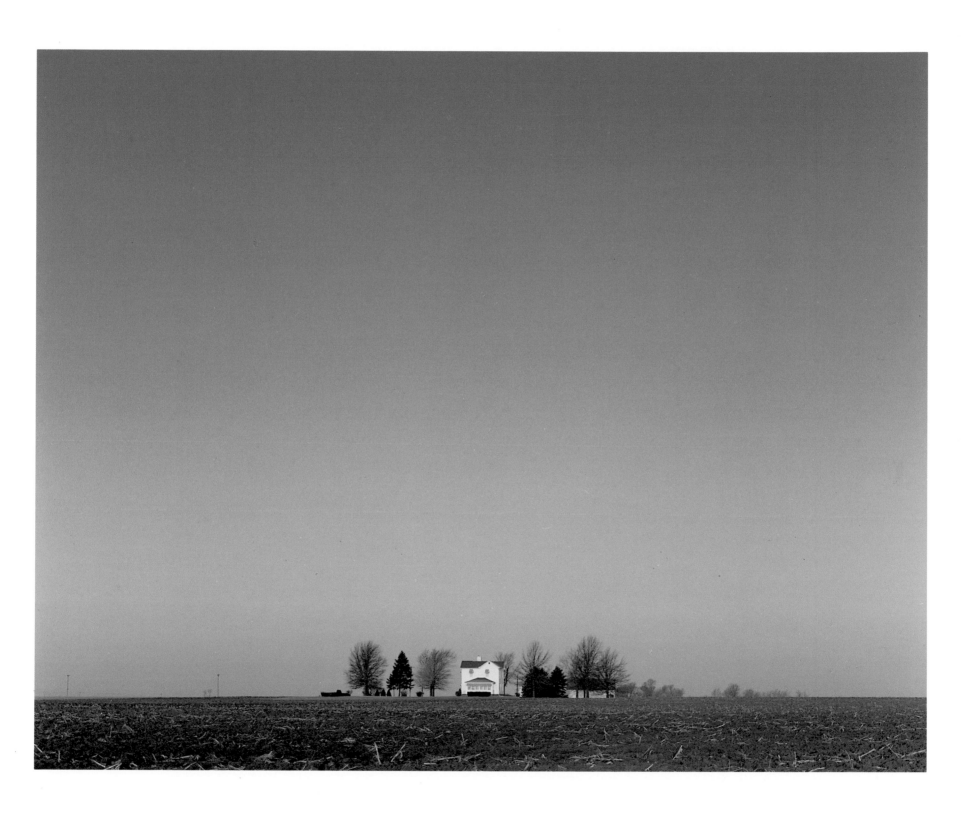

Oasis

3

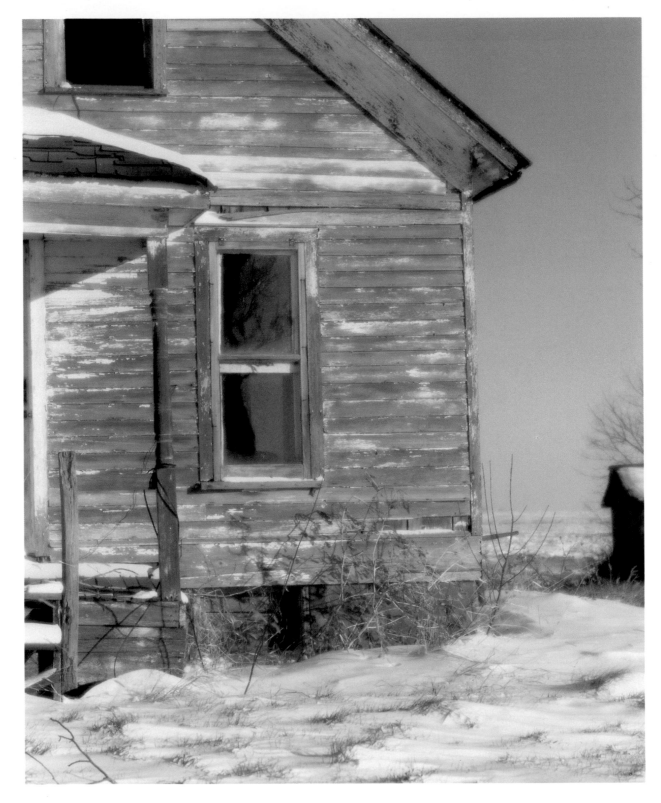

Prairie House

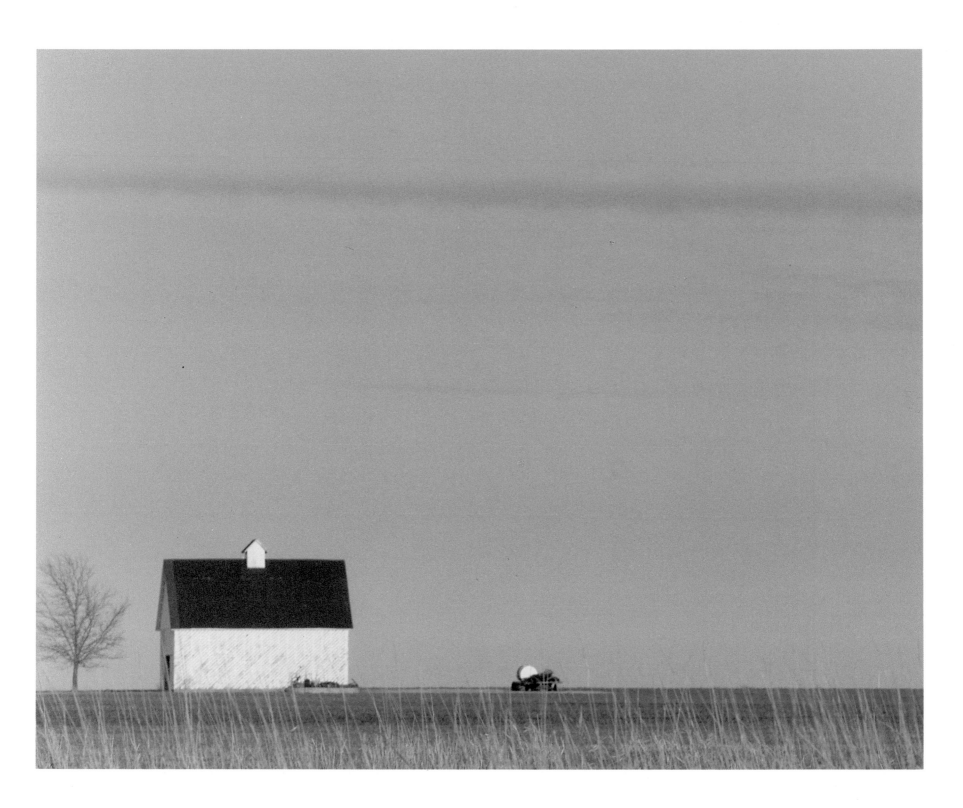

Countryside

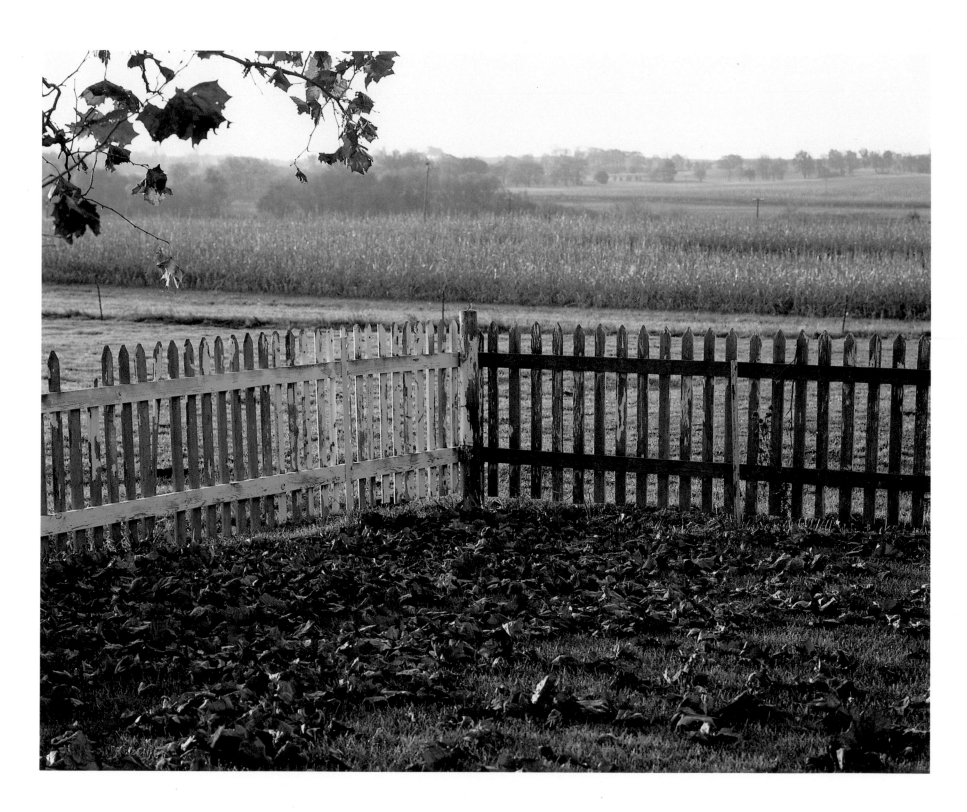

Backyard Sunrise

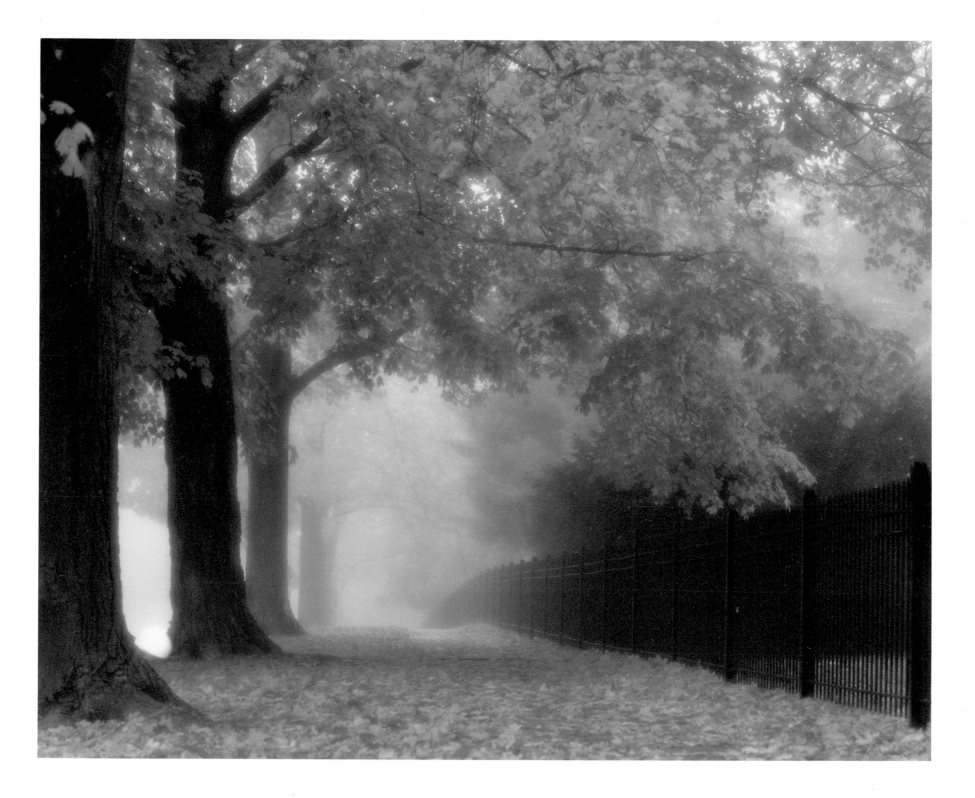

University and Prospect

7

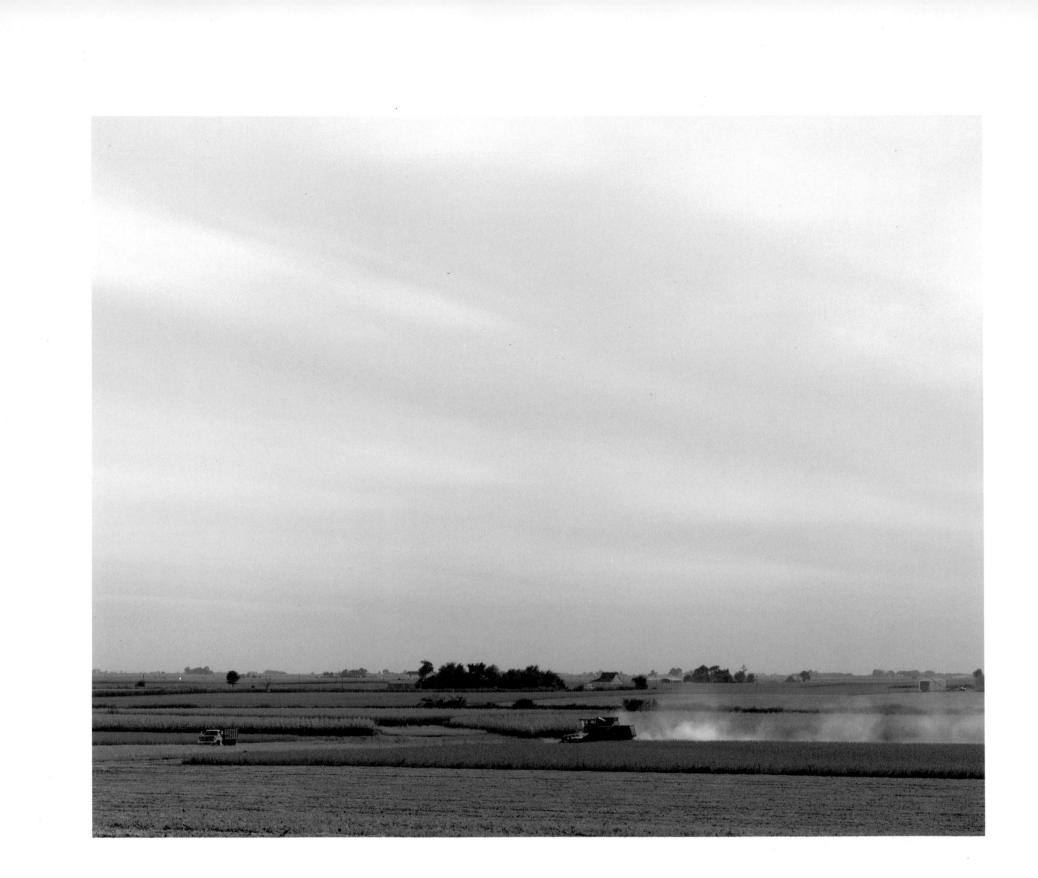

The Harvest

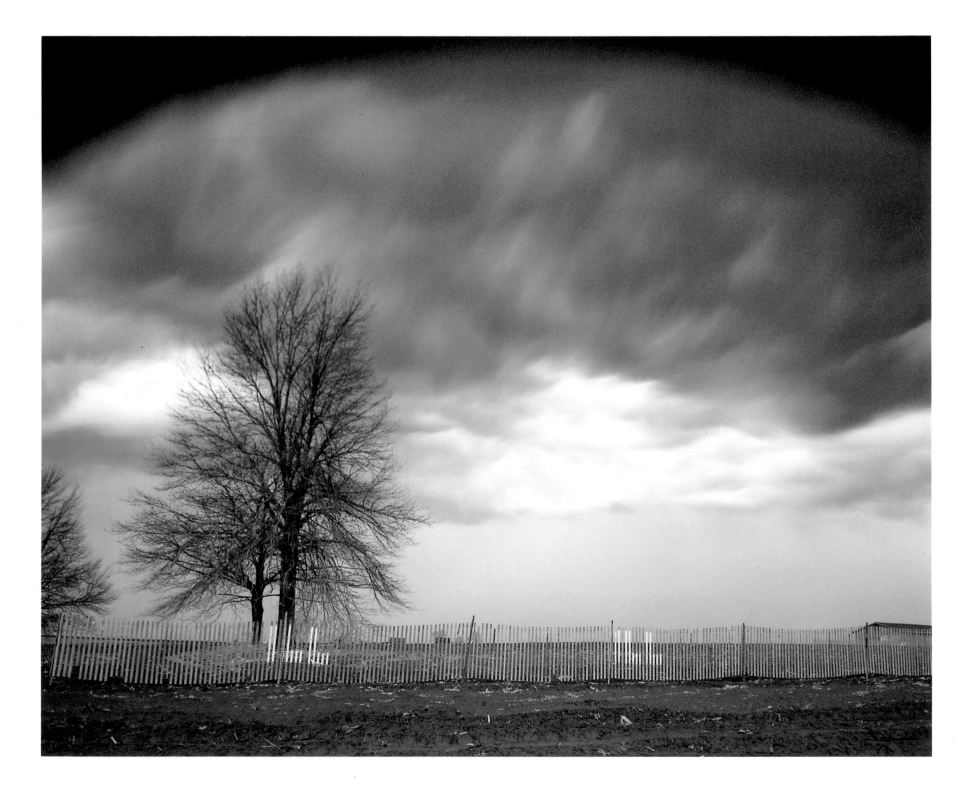

Tornado Watch

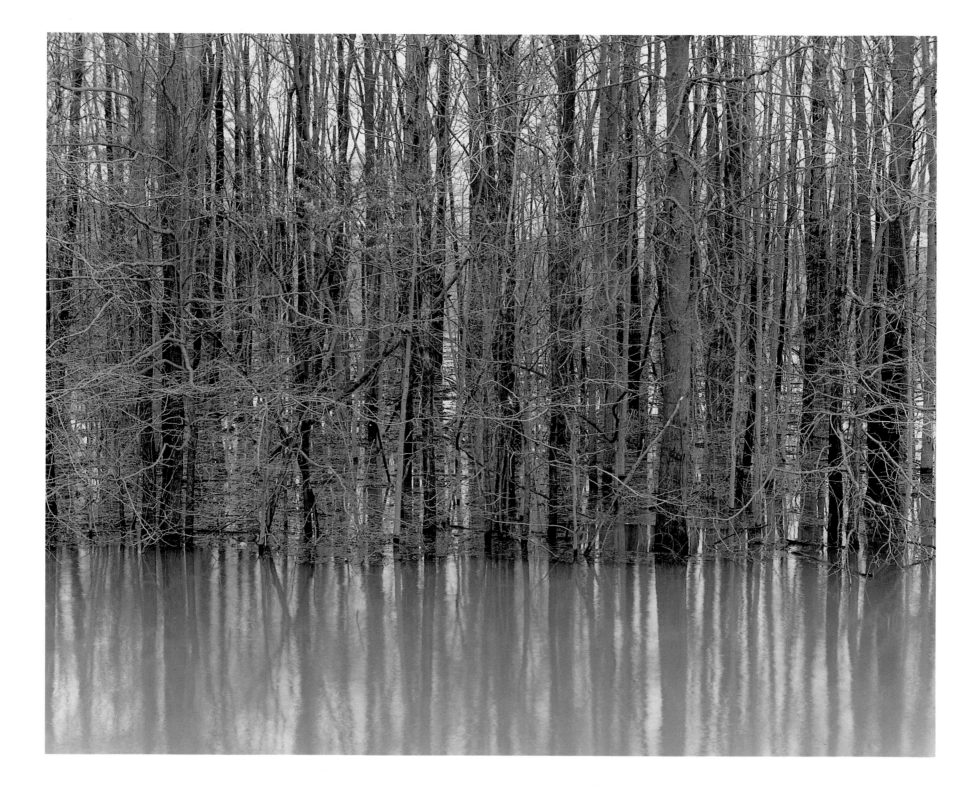

Bayou

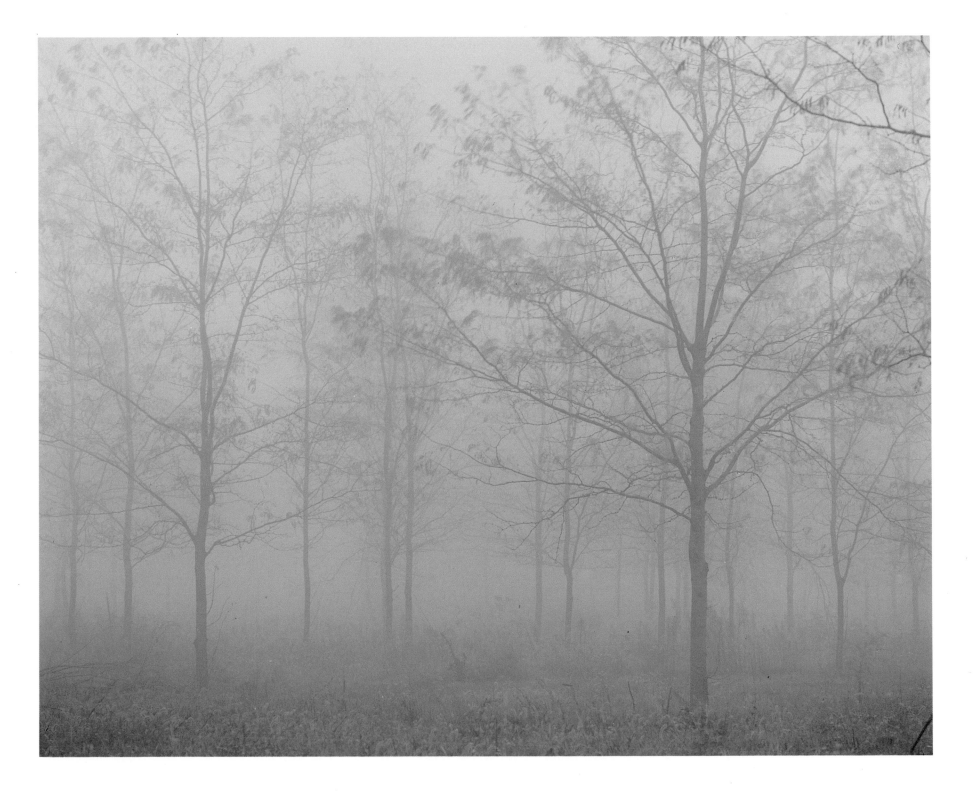

Bare Trees

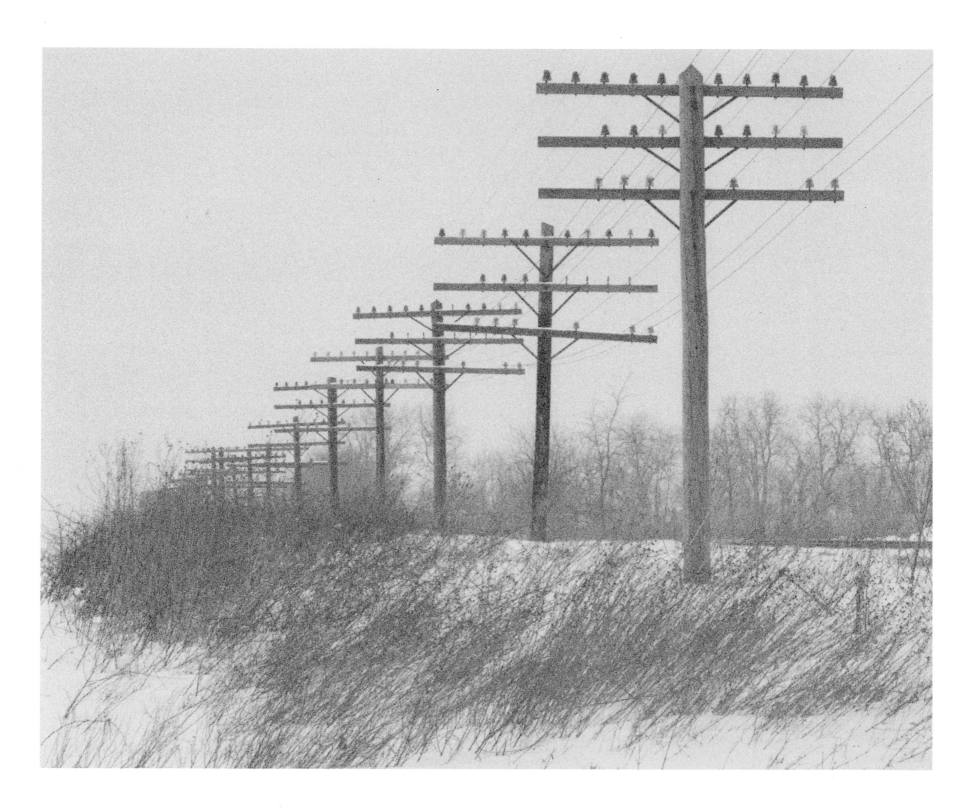

Pole Farm

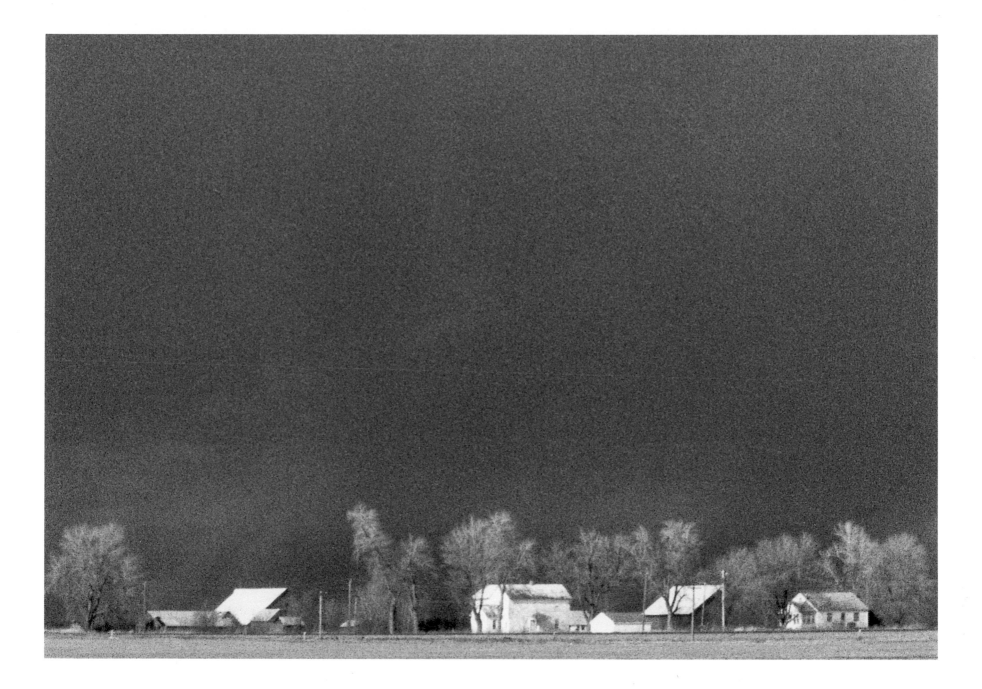

Blizzard of Oz

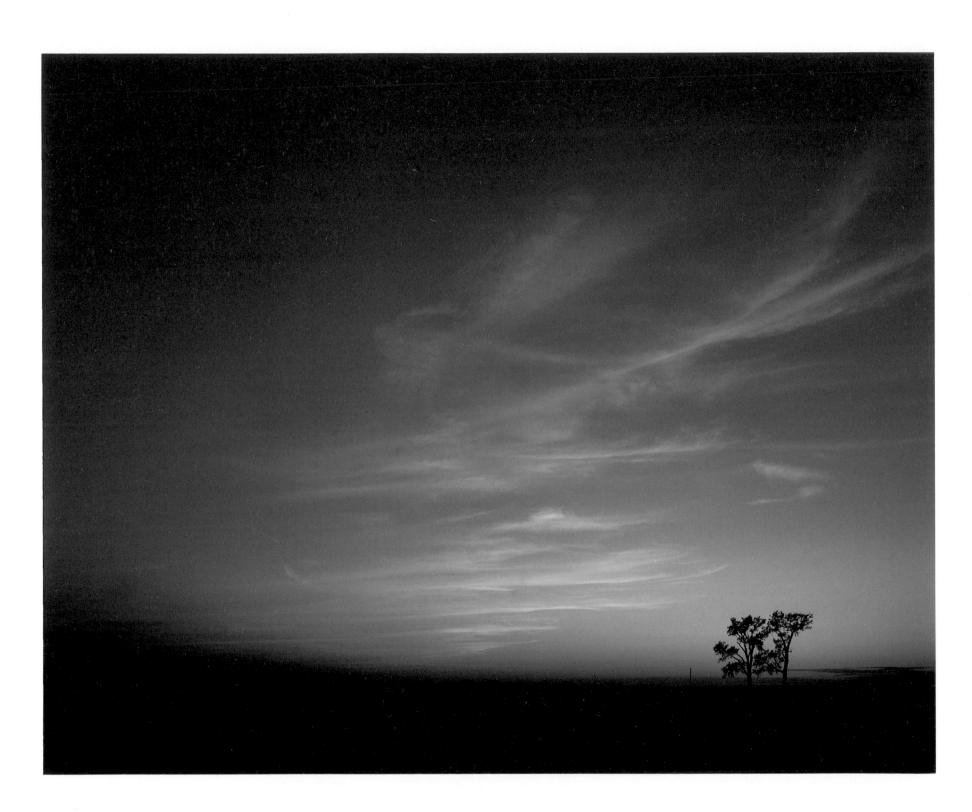

Windsor Sunset

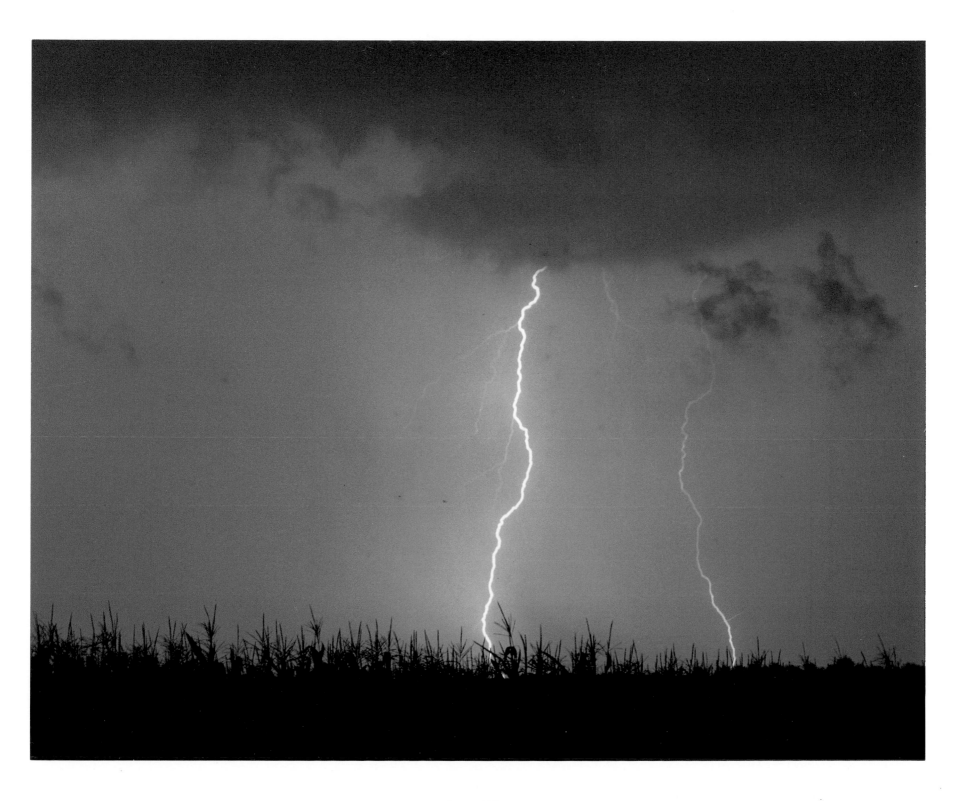

Grounded

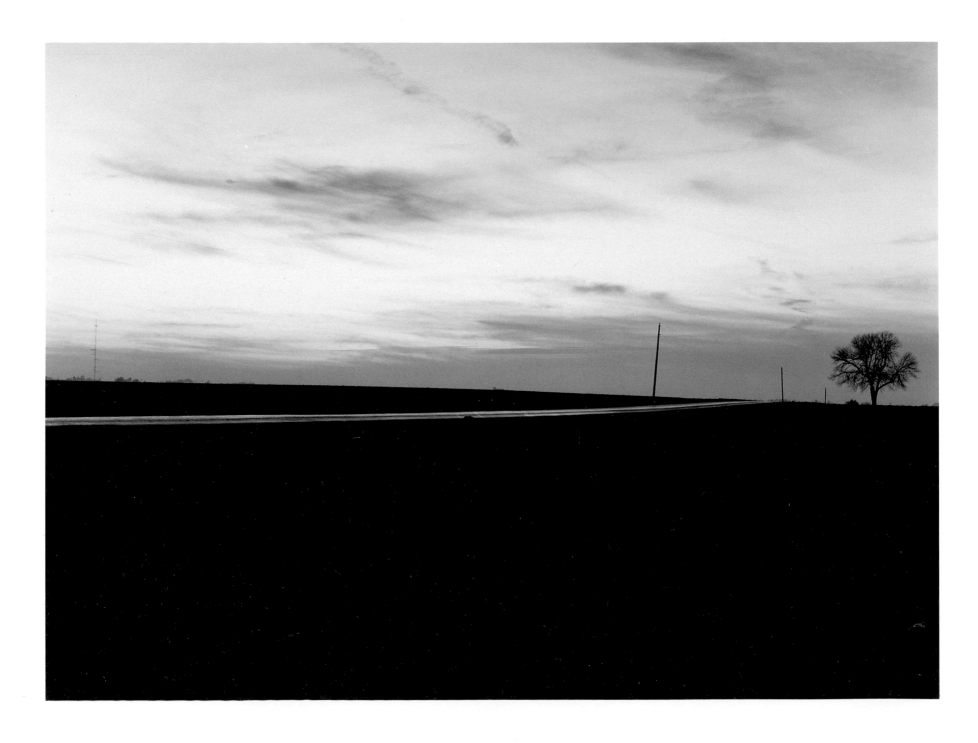

Twilight

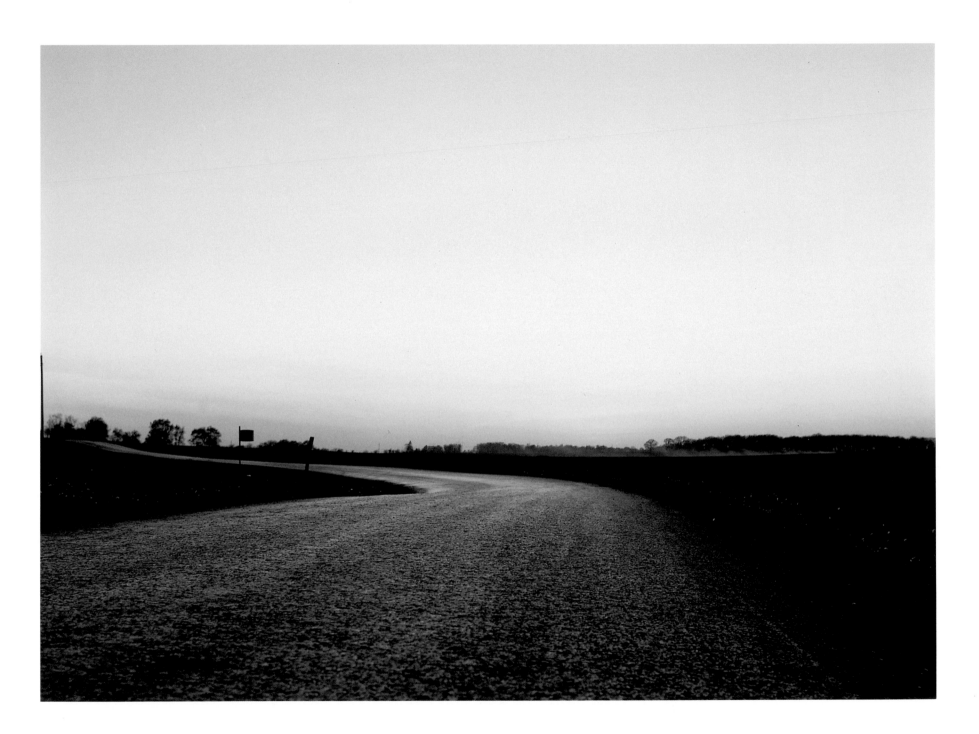

Magic Road

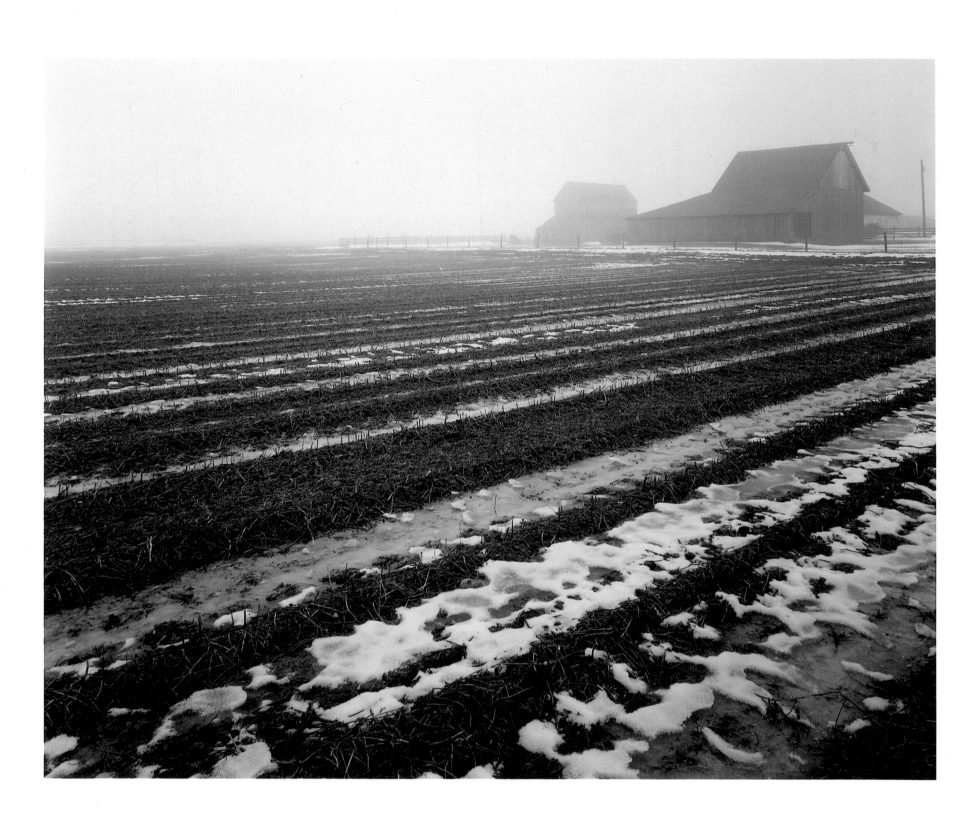

Kirby and Mattis

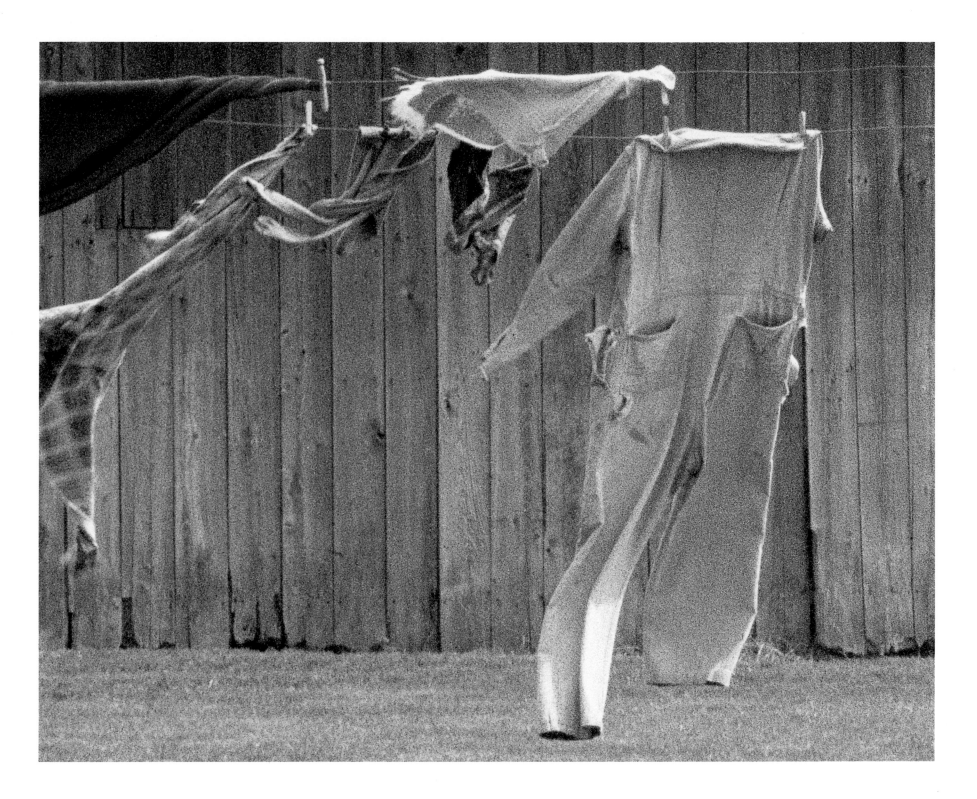

On the Line

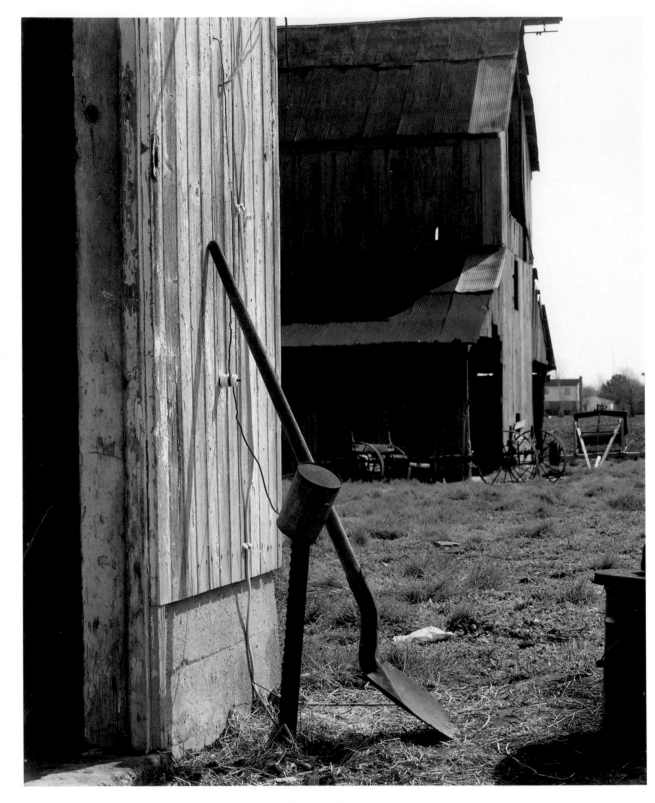

Country Afternoon

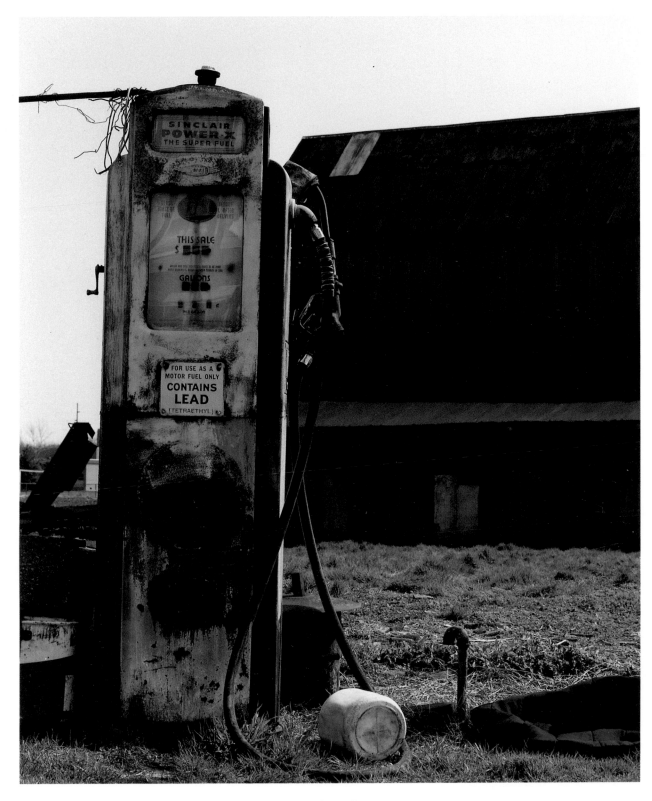

Gasoline Alley

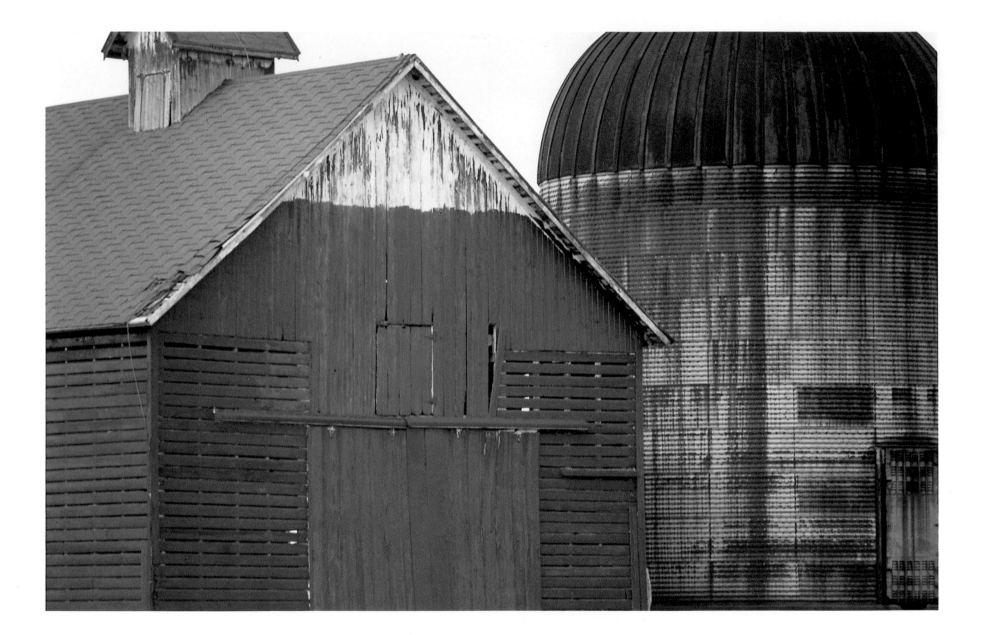

Windsor Barn

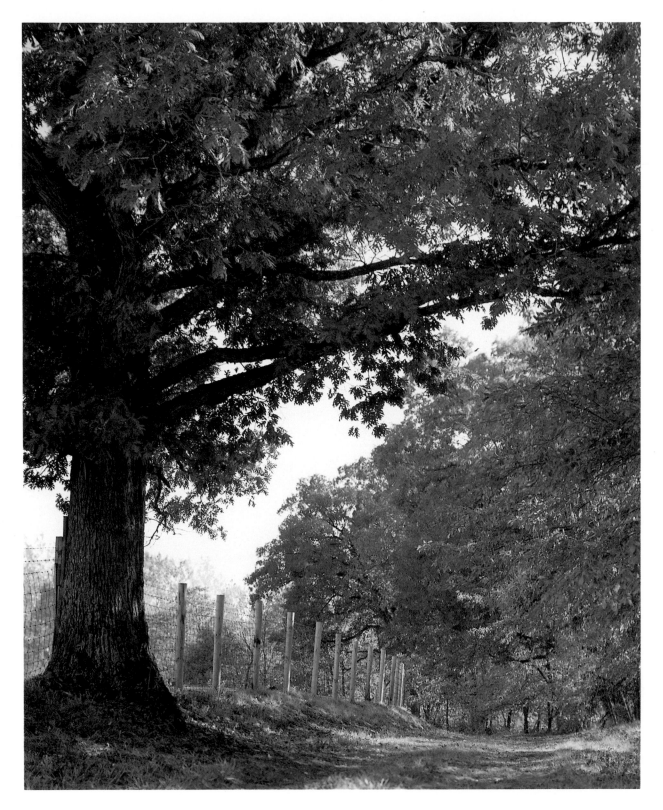

Oakwood

23

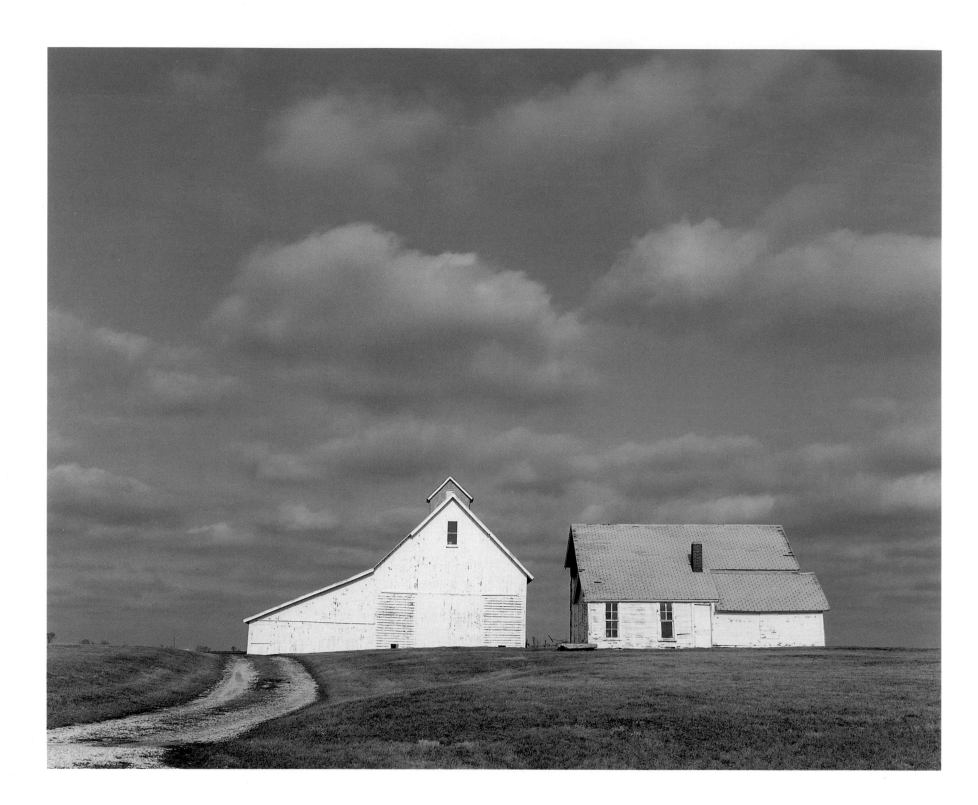

Royal Farmstead

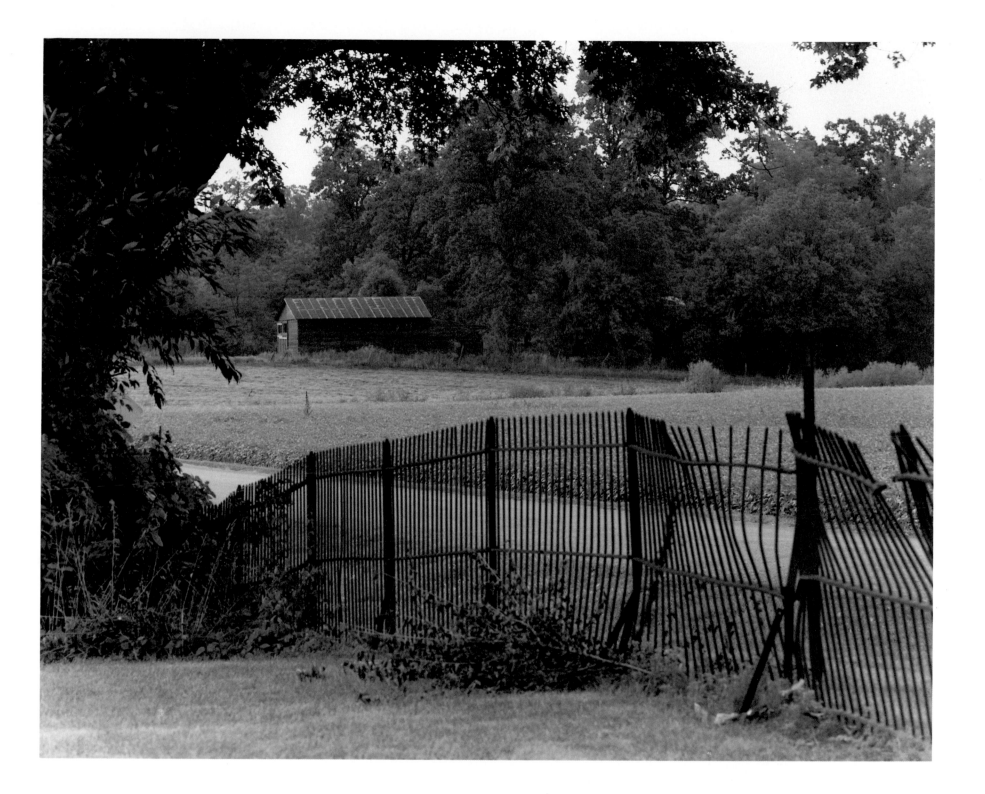

The Back Way

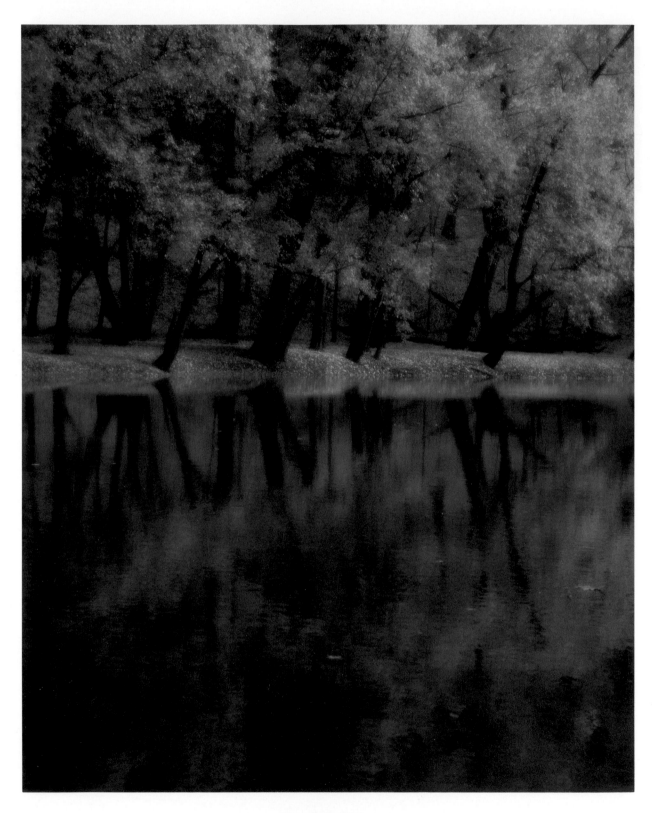

River Reflections

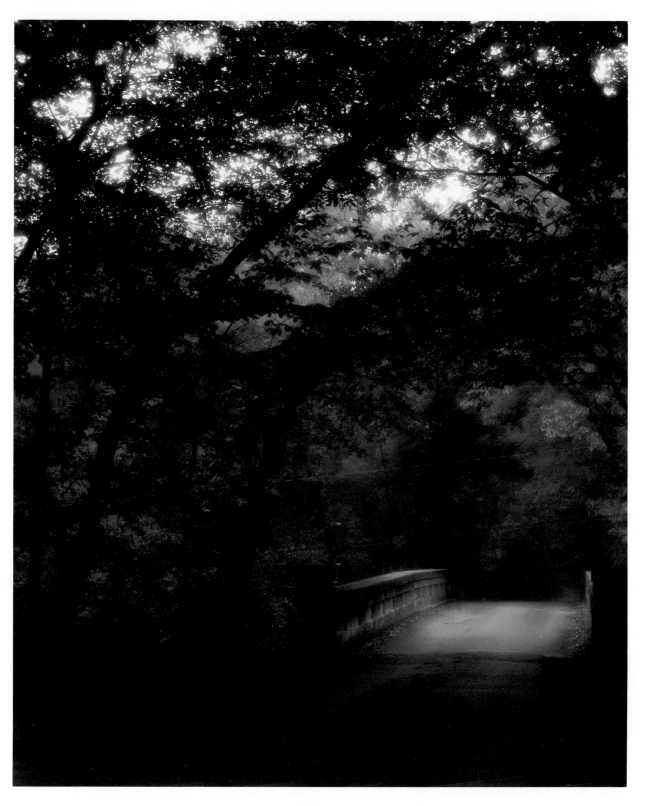

Allerton

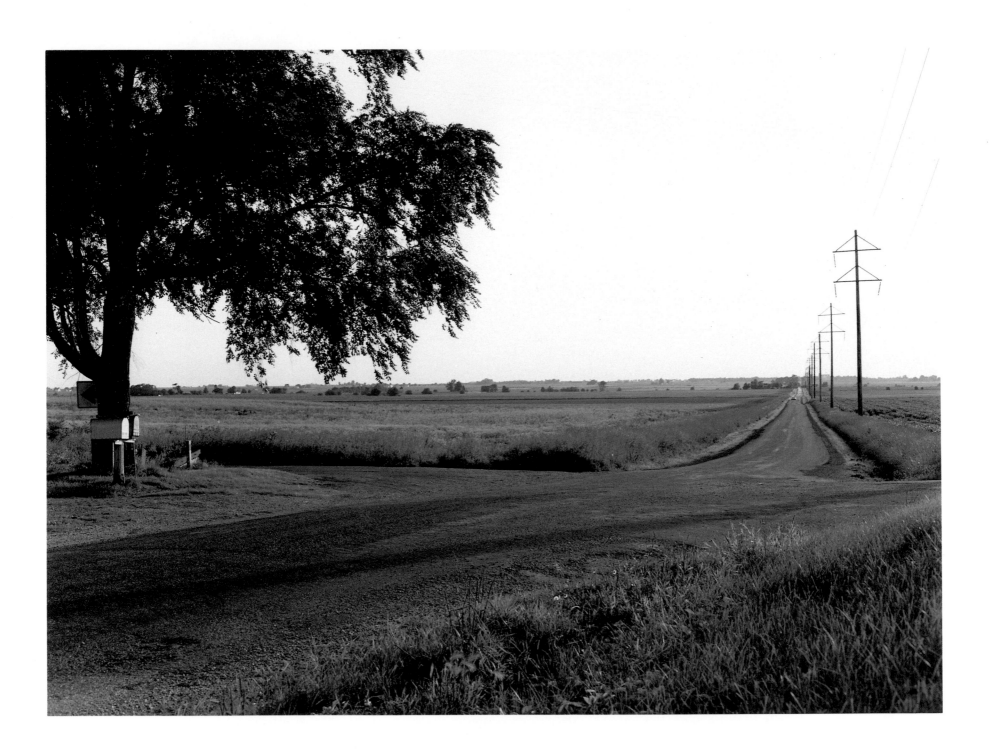

Crossroads

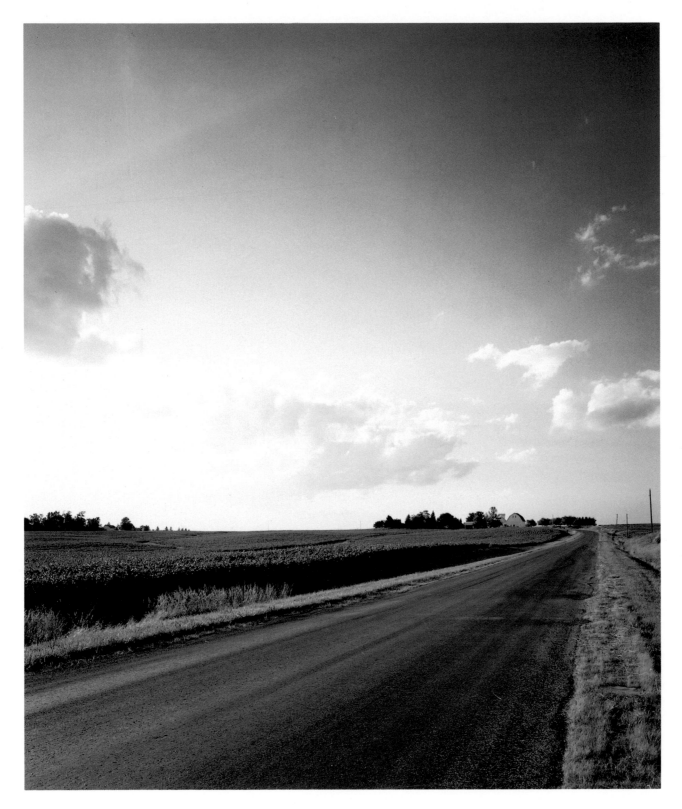

Parrott Farm

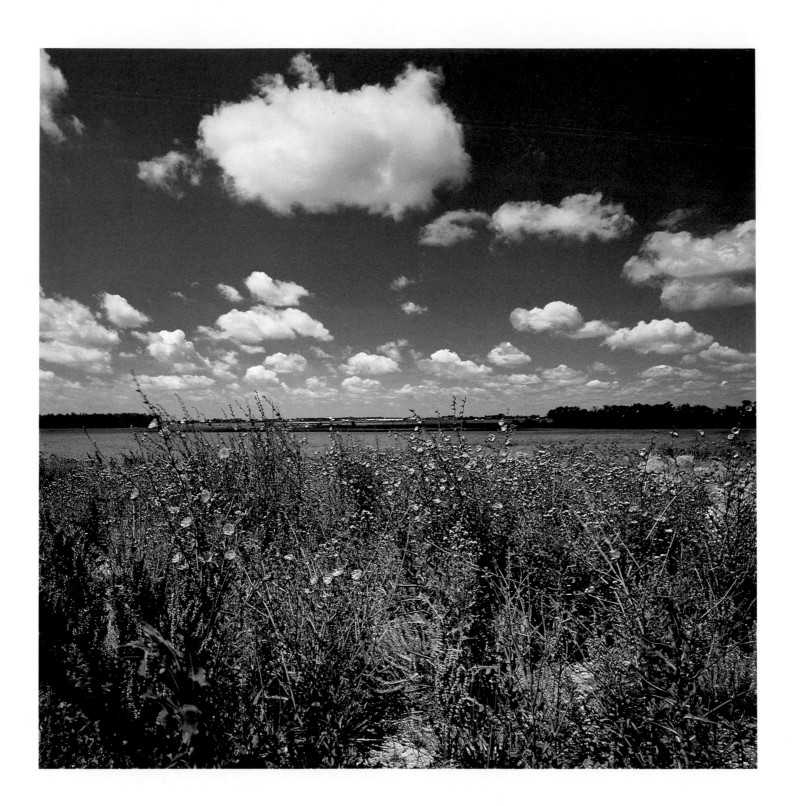

Prairie Grass

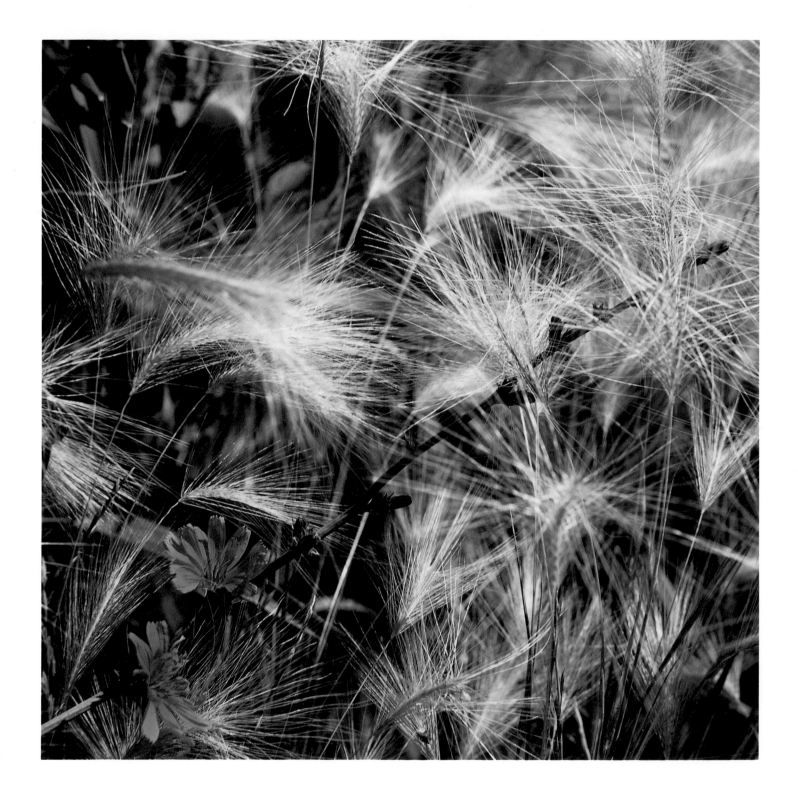

Prairie Flowers

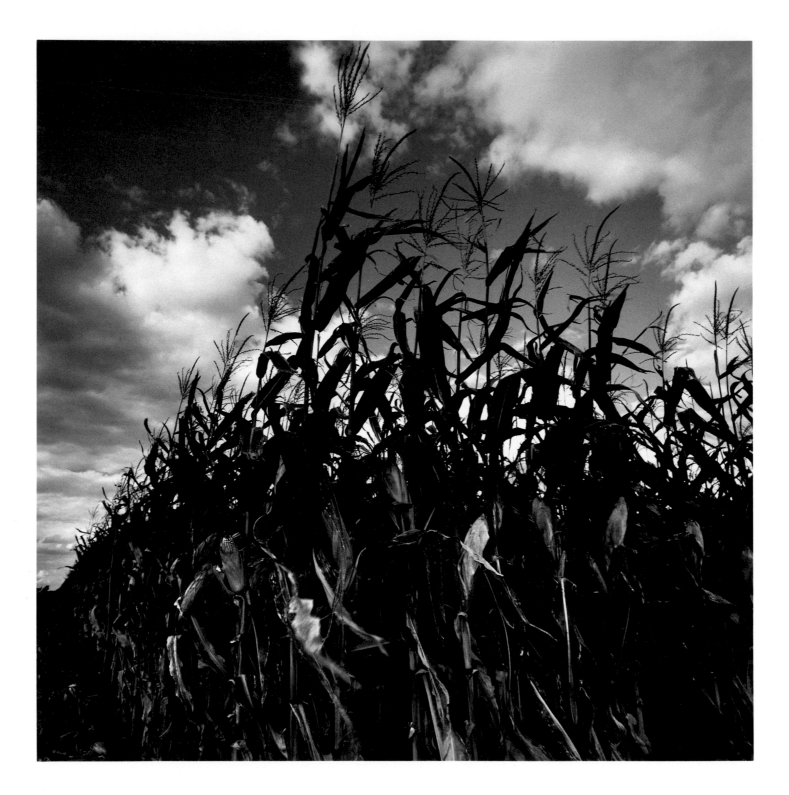

Skyscrapers

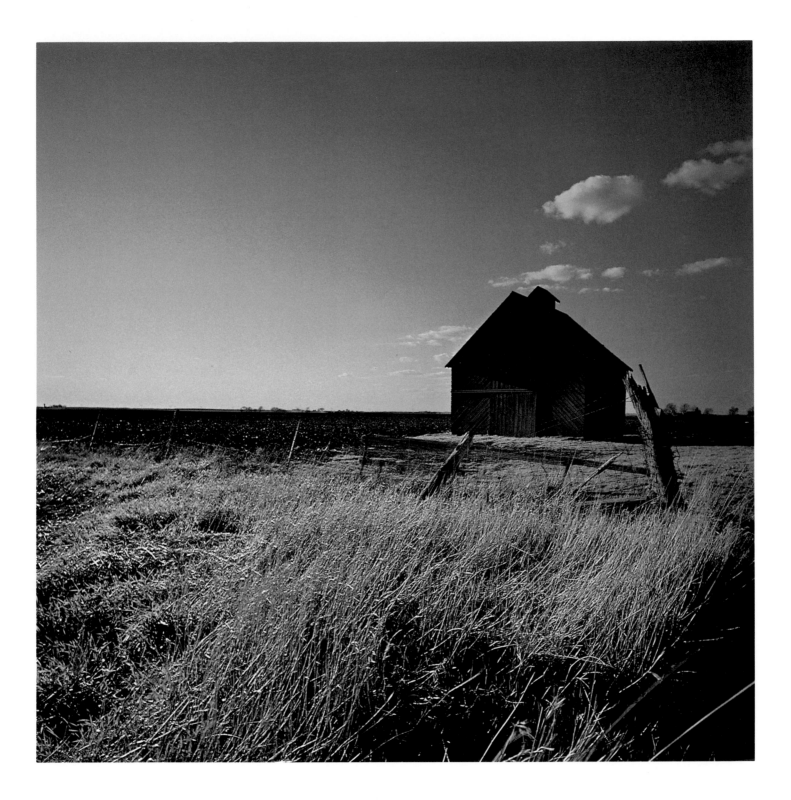

Over the Post

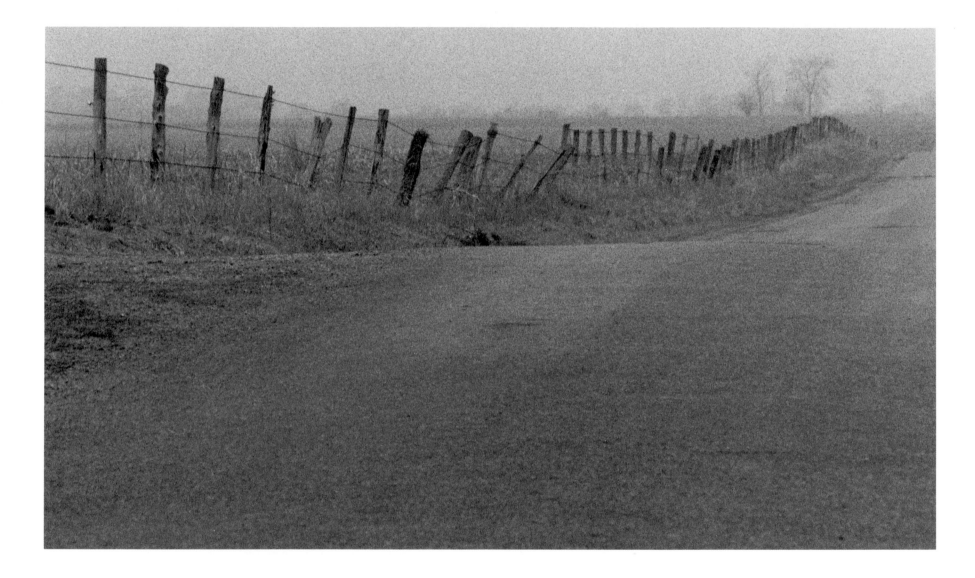

Fencerow

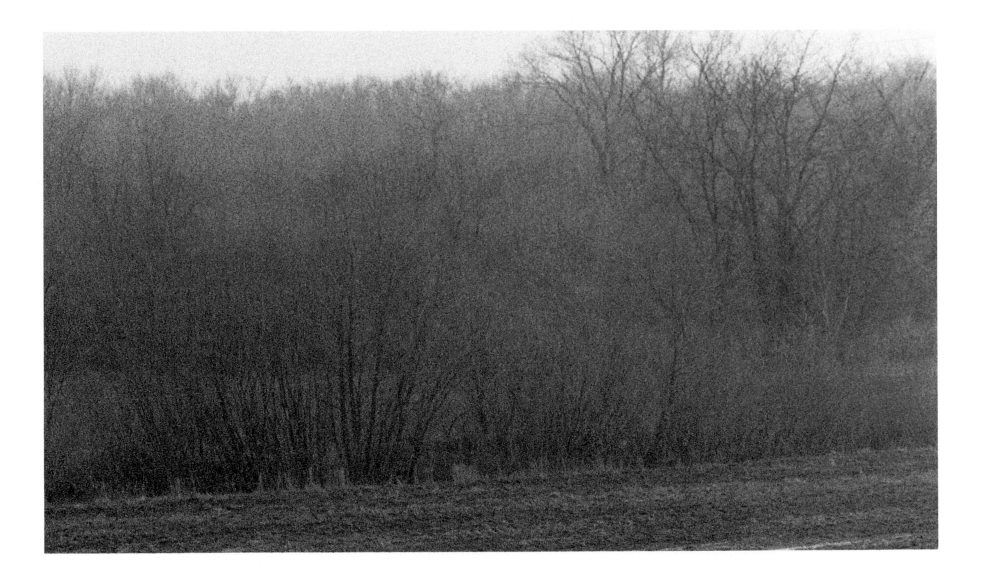

Painted Trees

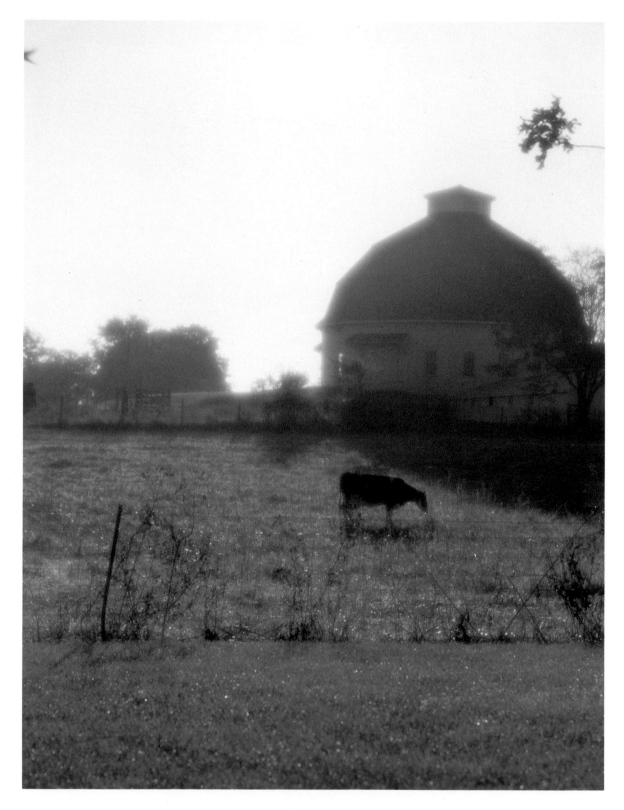

Round Barn

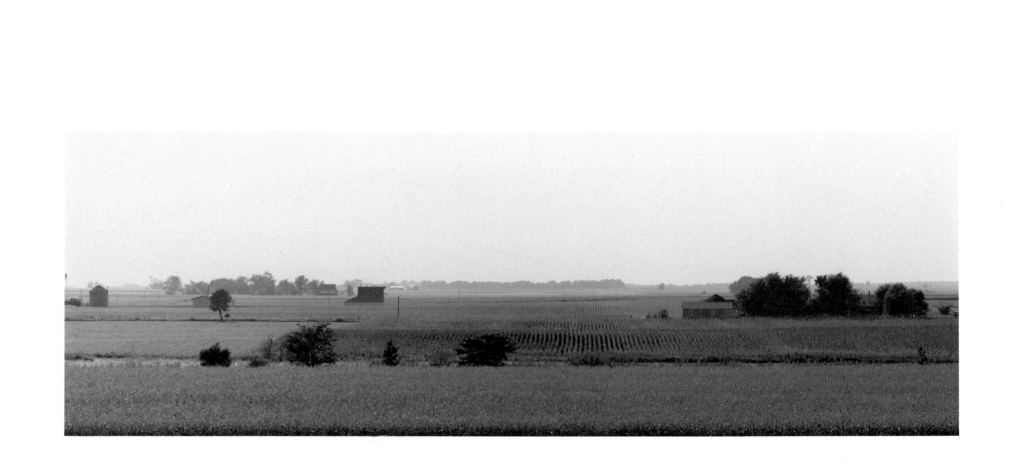

Midwest Vista

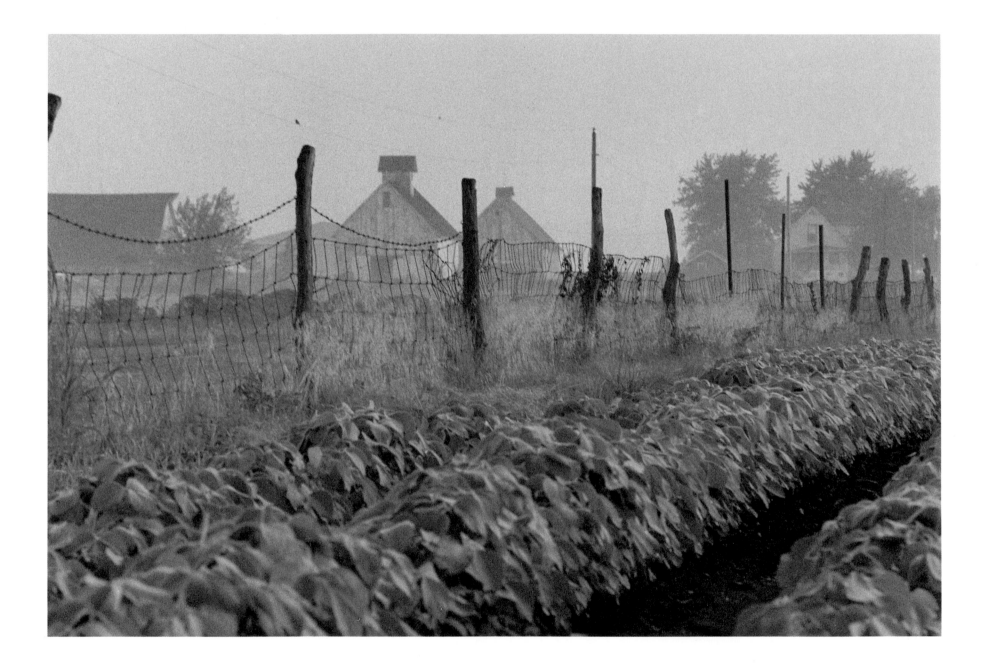

Heartland Daybreak

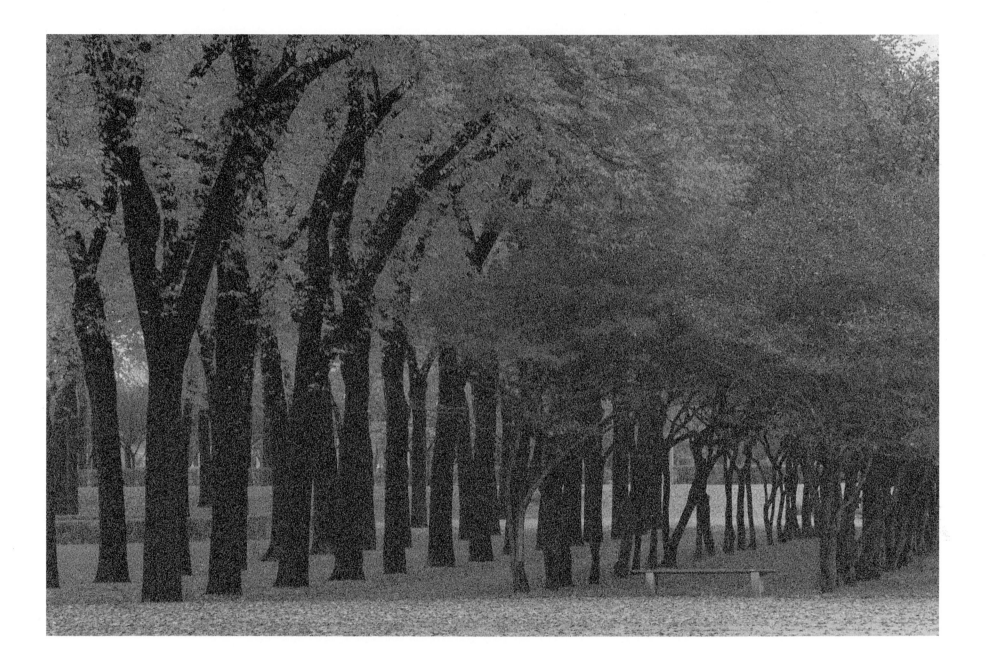

City Harbor

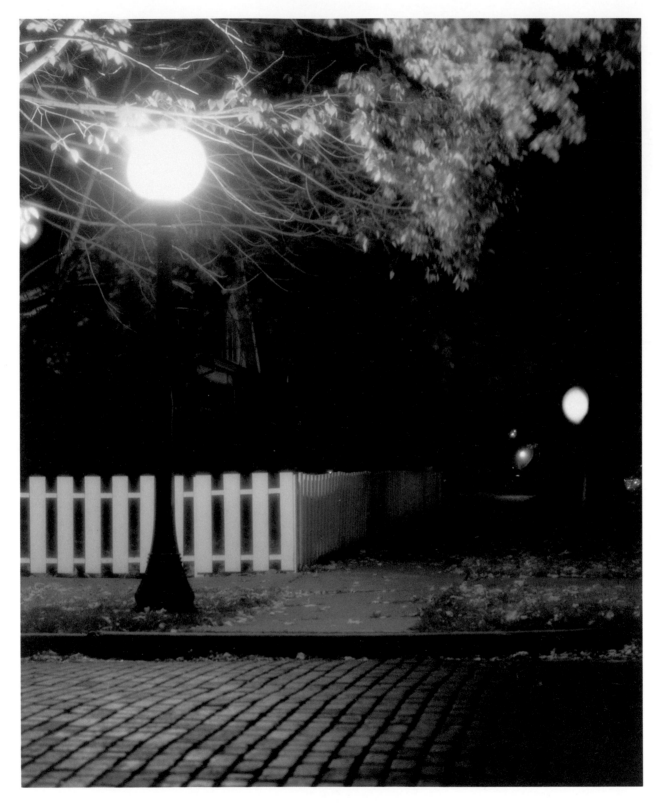

Hill Street Light

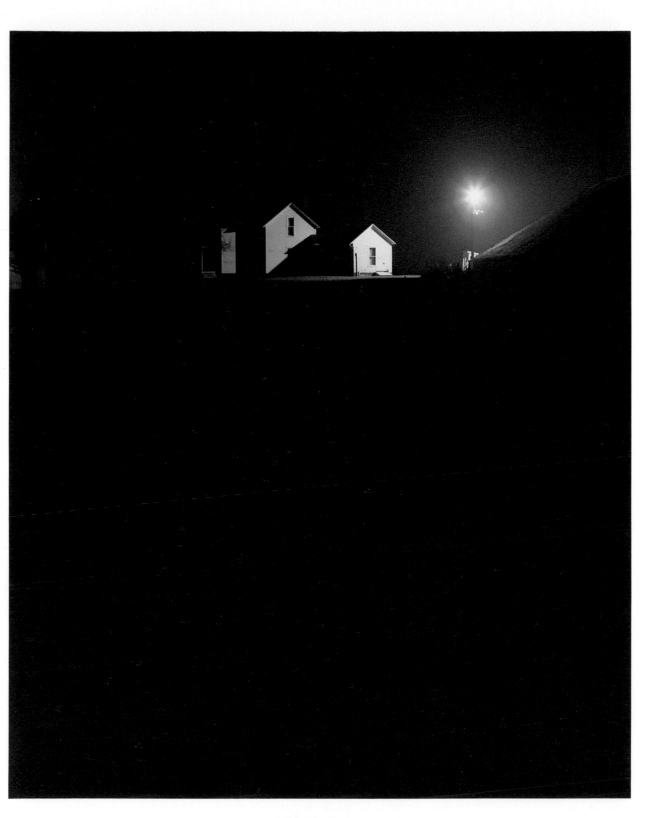

Midnight Oasis

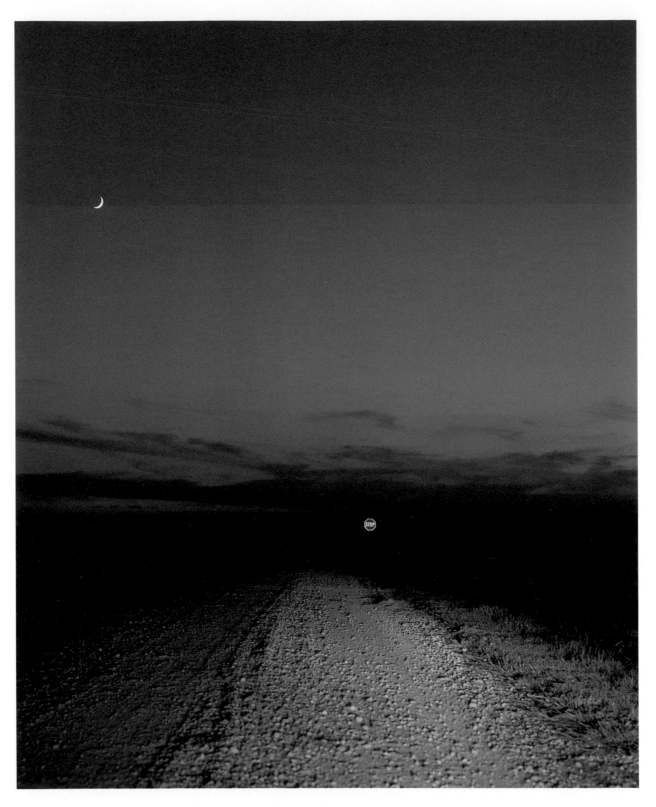

Stop Moon Crossing

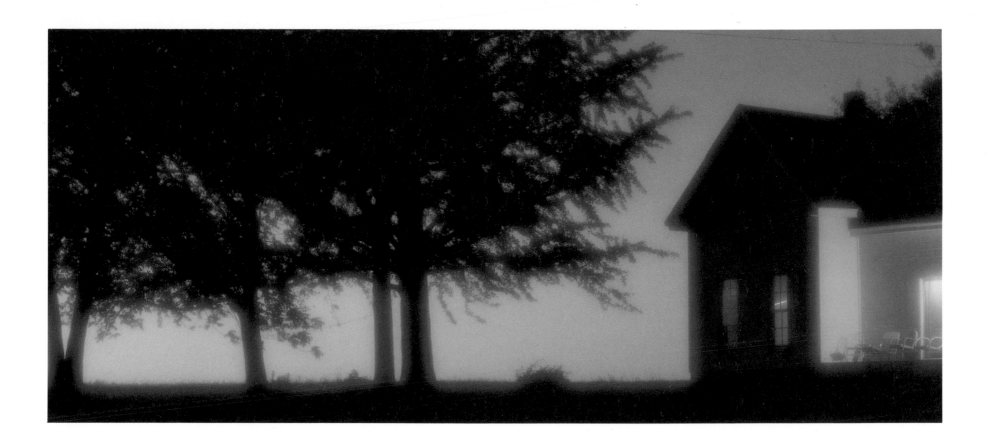

Sunset House

43

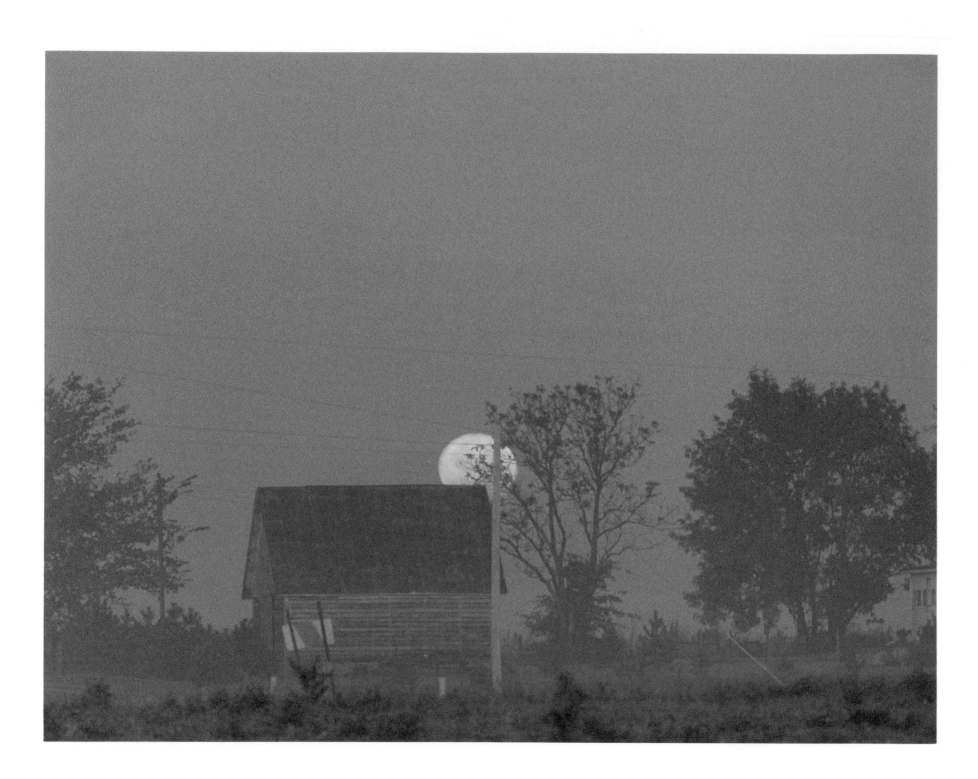

Hunter's Moon Rising

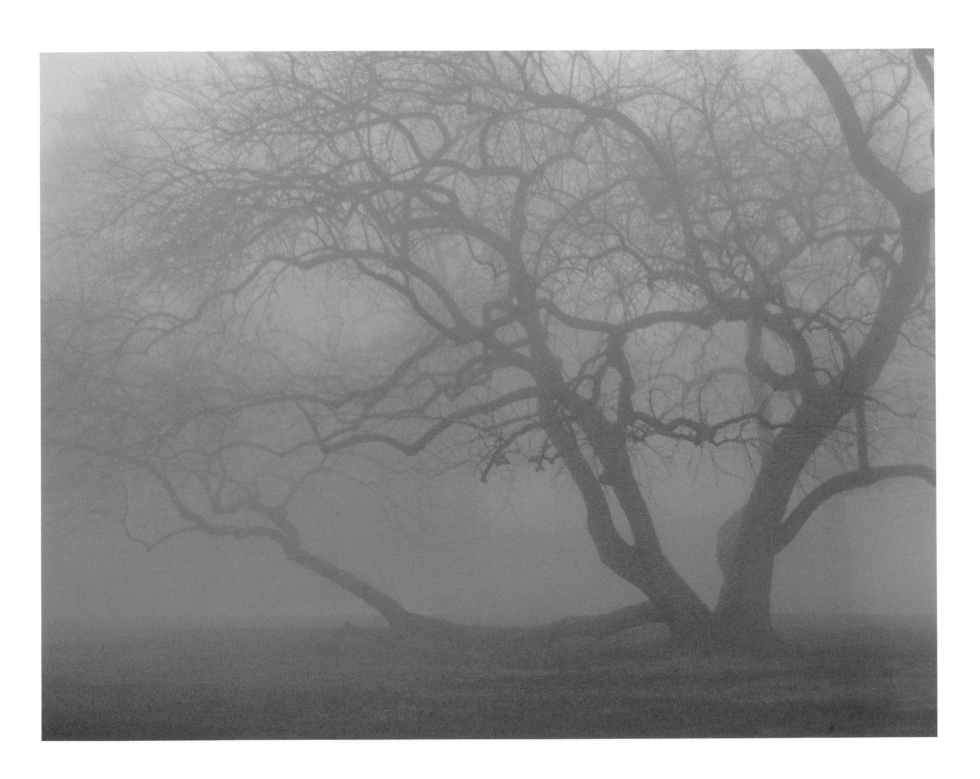

Compass Tree

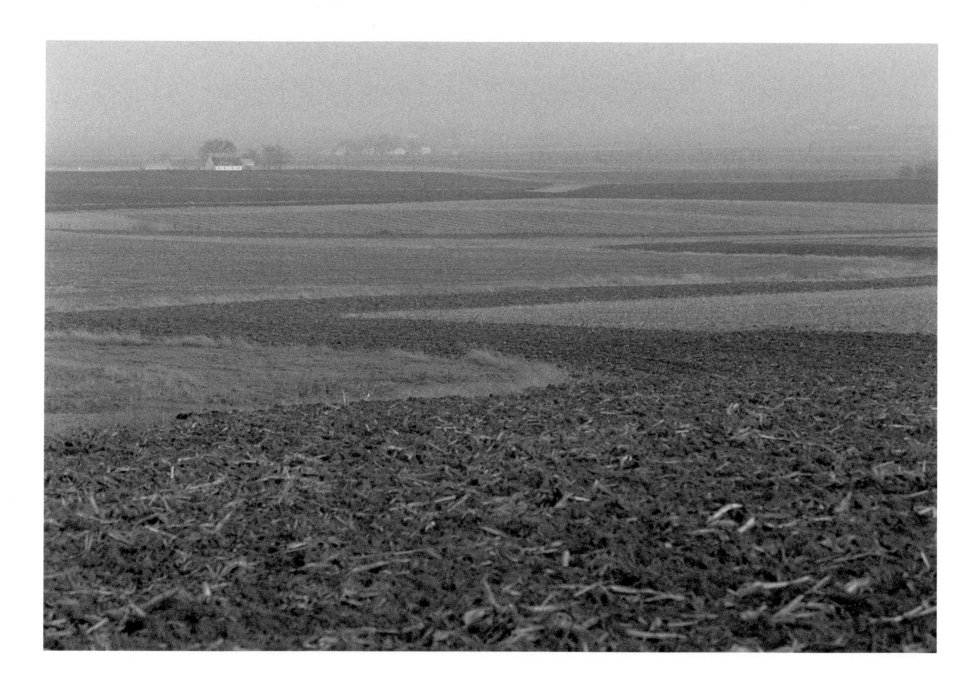

On the Heights

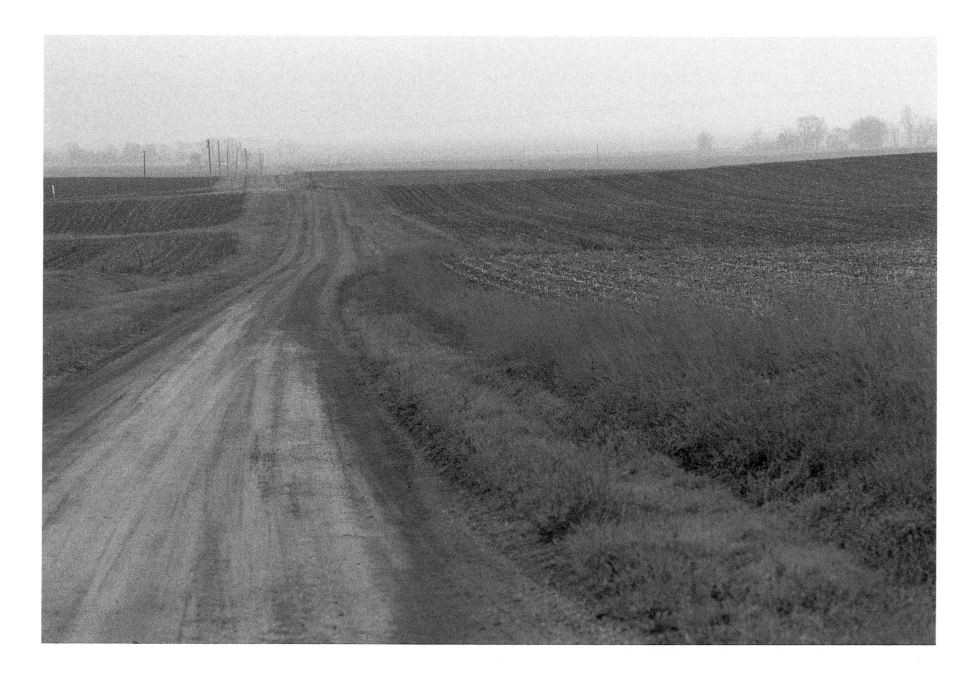

County Line Road

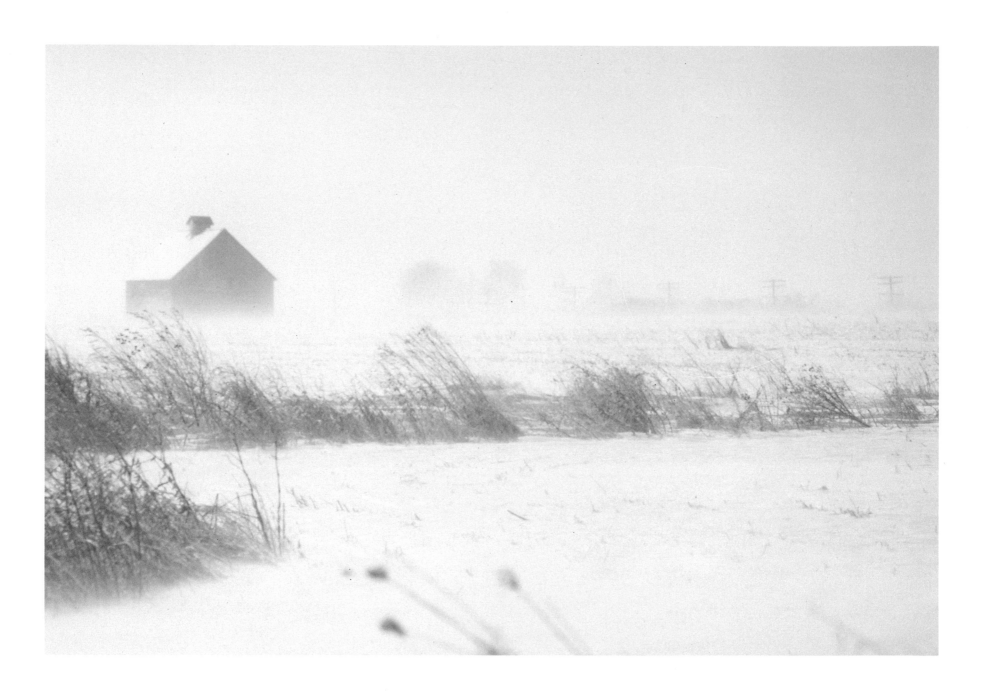

Blizzard, Rte. 45

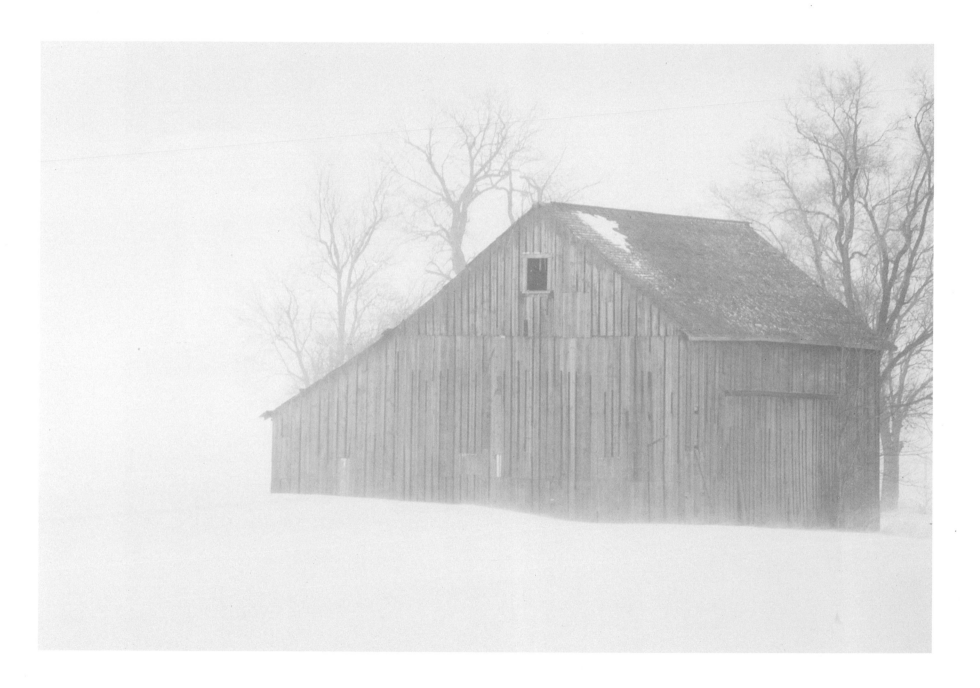

Staley Blizzard

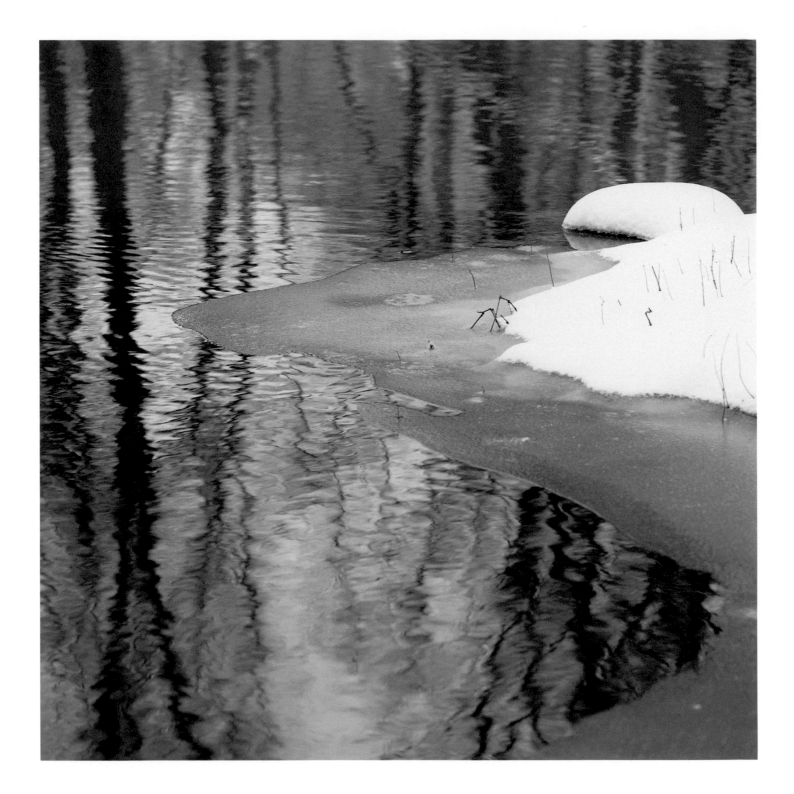

Winter Morning I

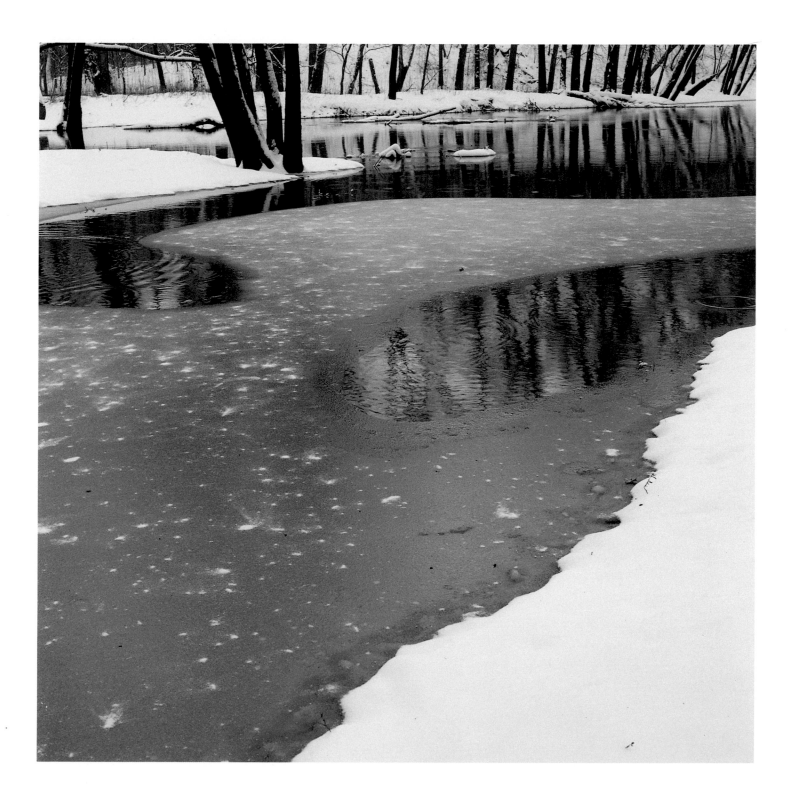

Winter Morning II

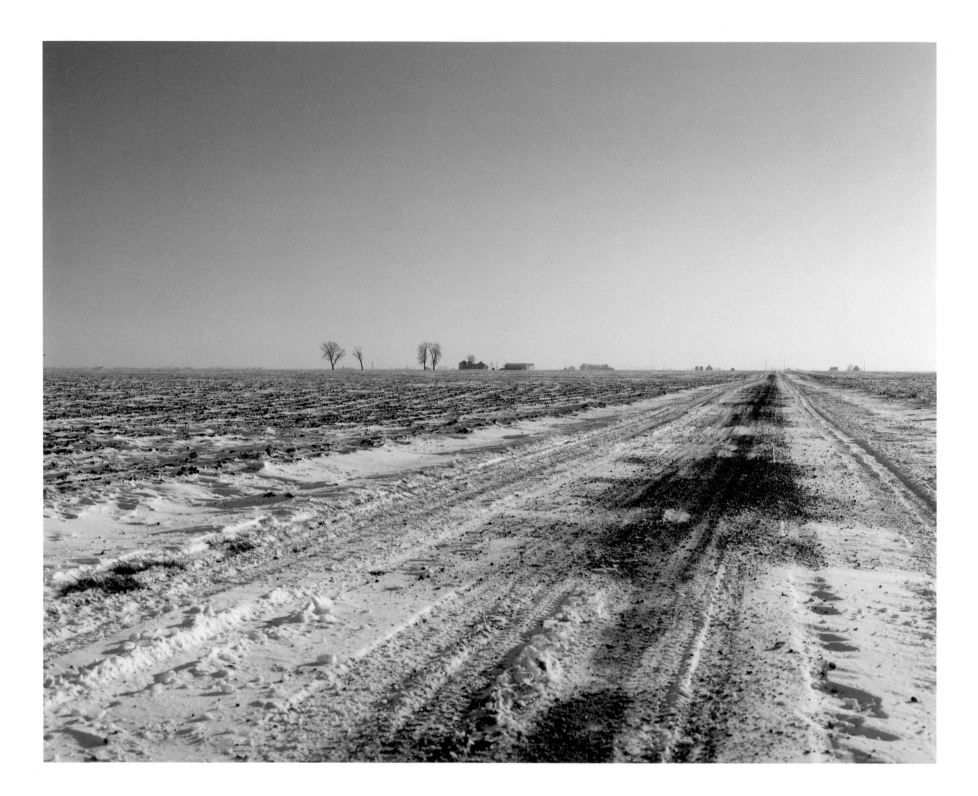

Winter Road

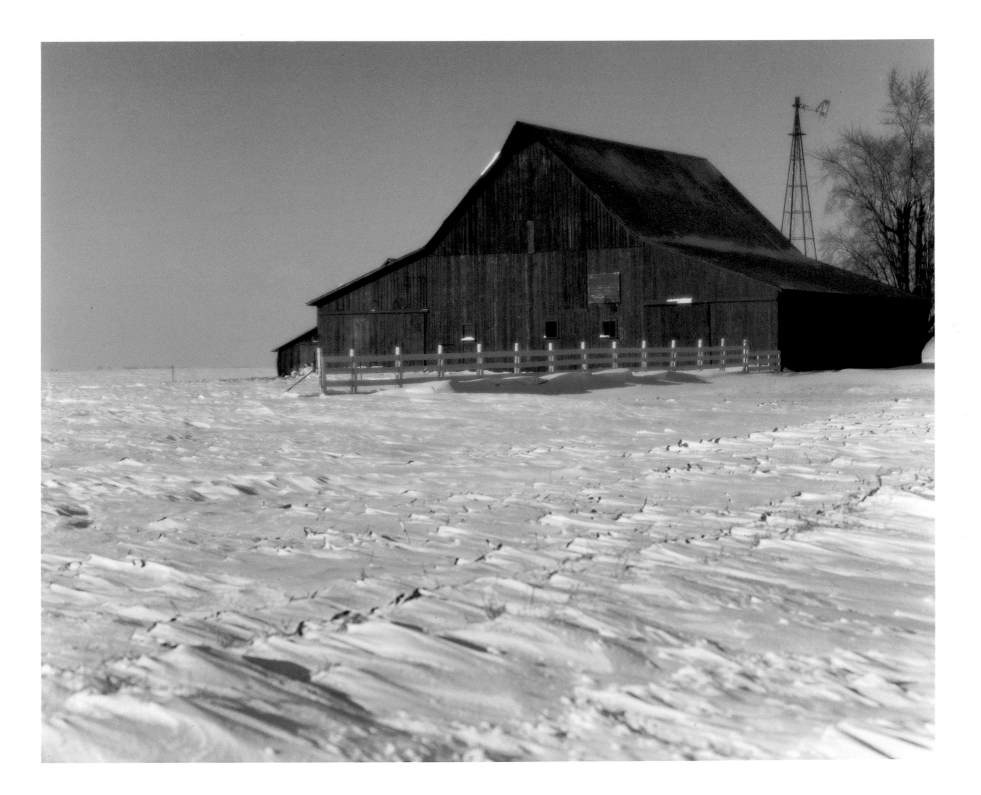

Meese Farm

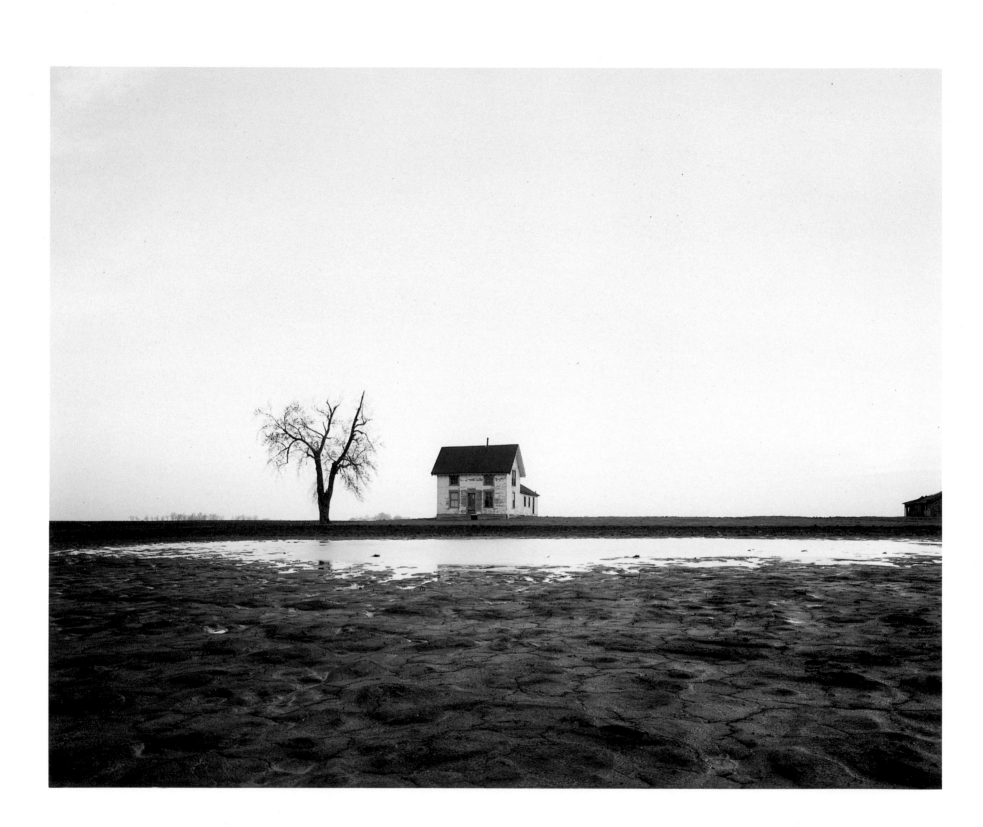

Loner

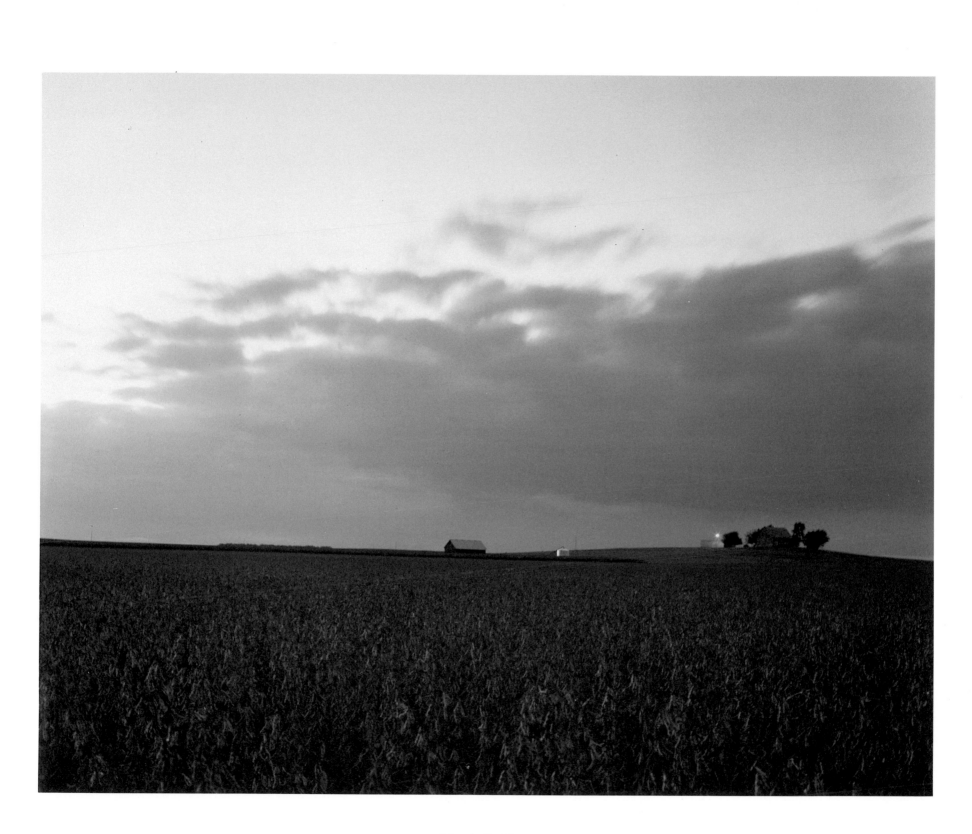

Monticello Rise

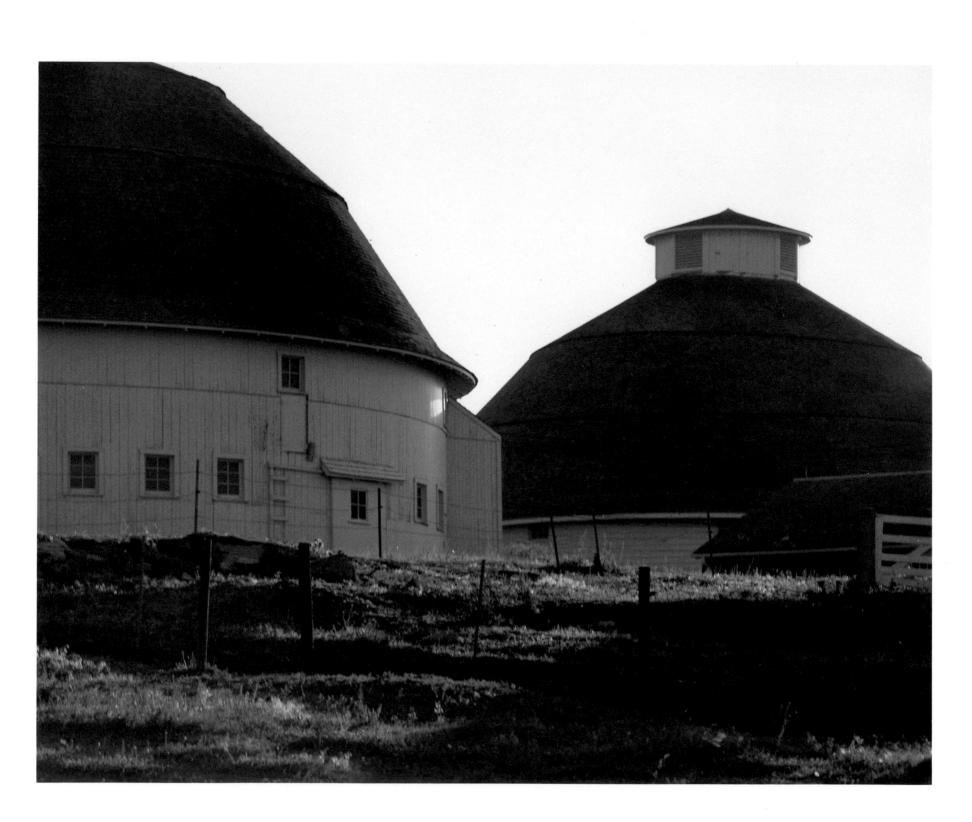

South Farms

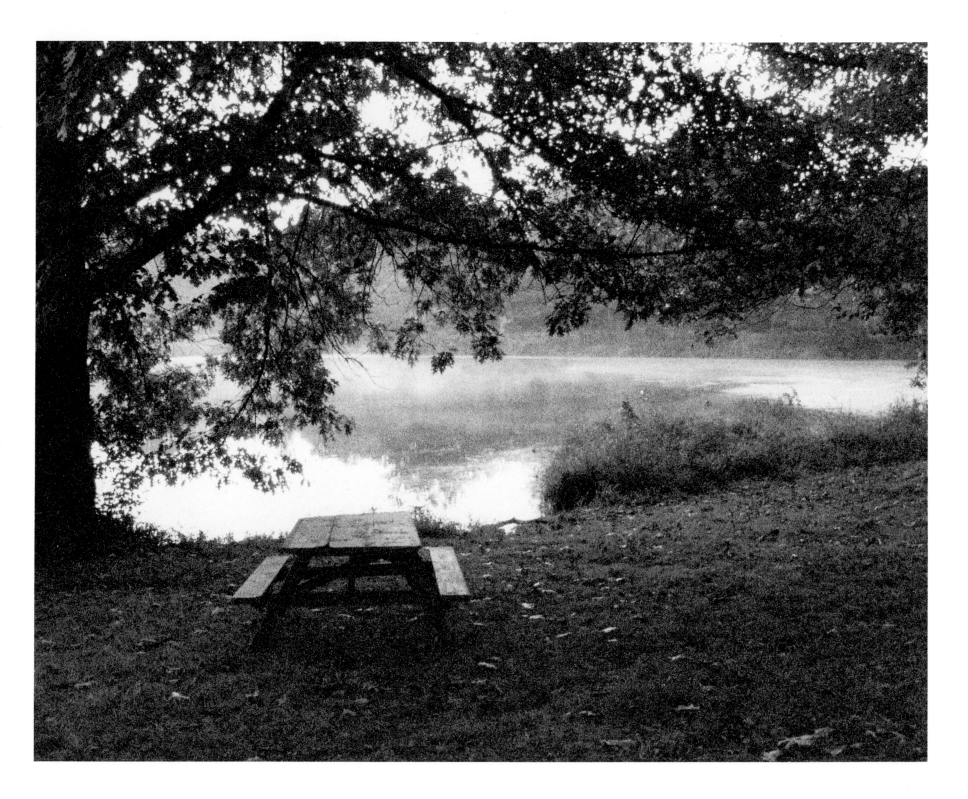

Romantic Retreat

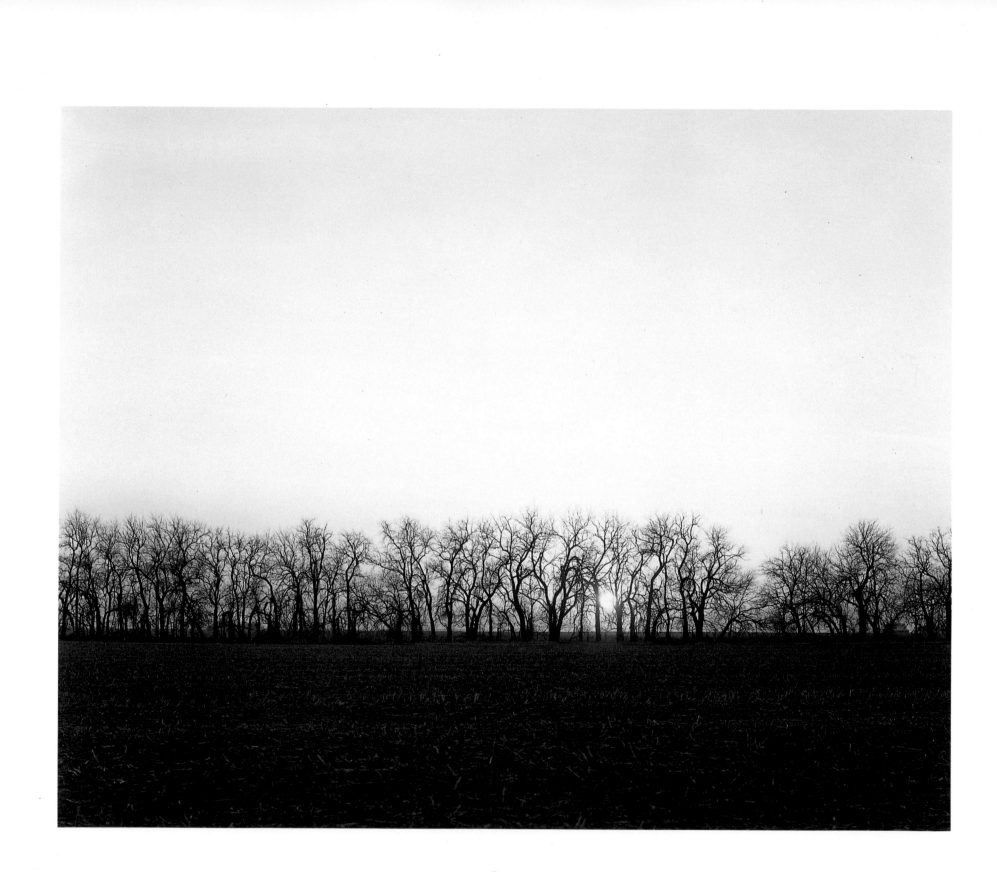

Osage

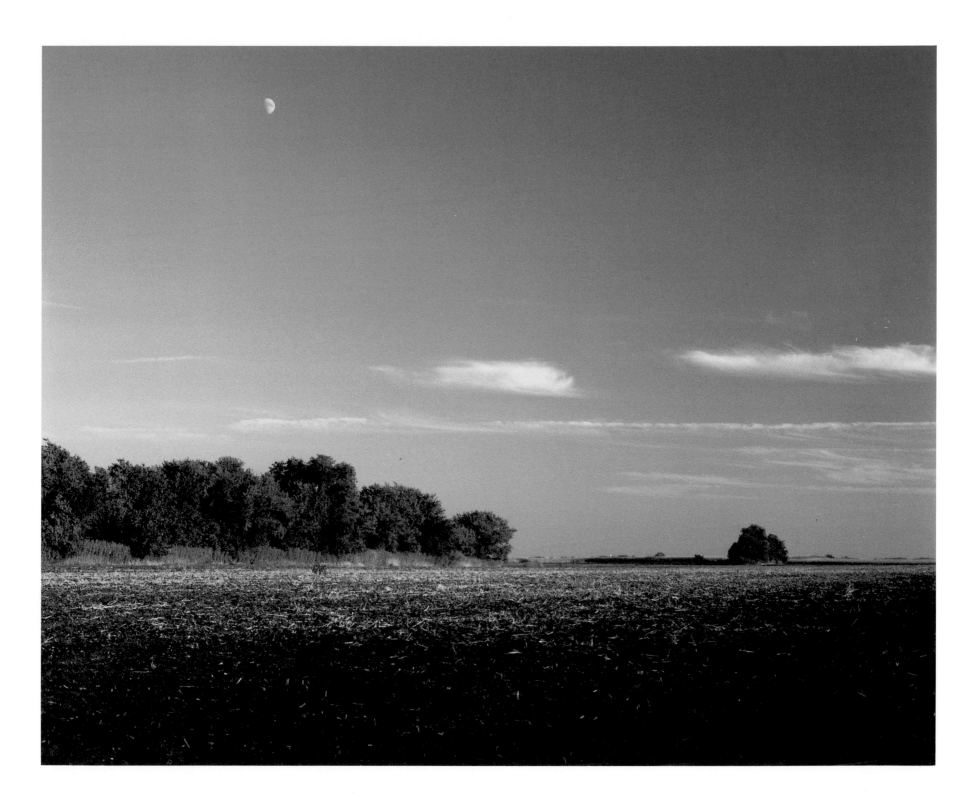

Bare Field under Harvest Moon

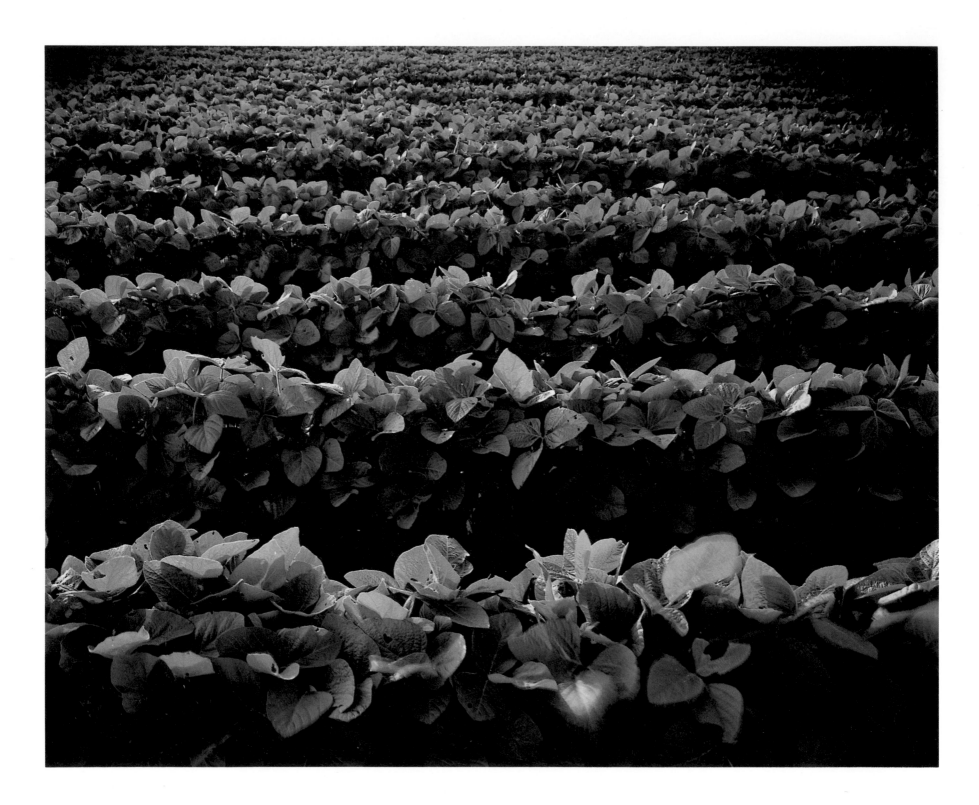

Soybeans

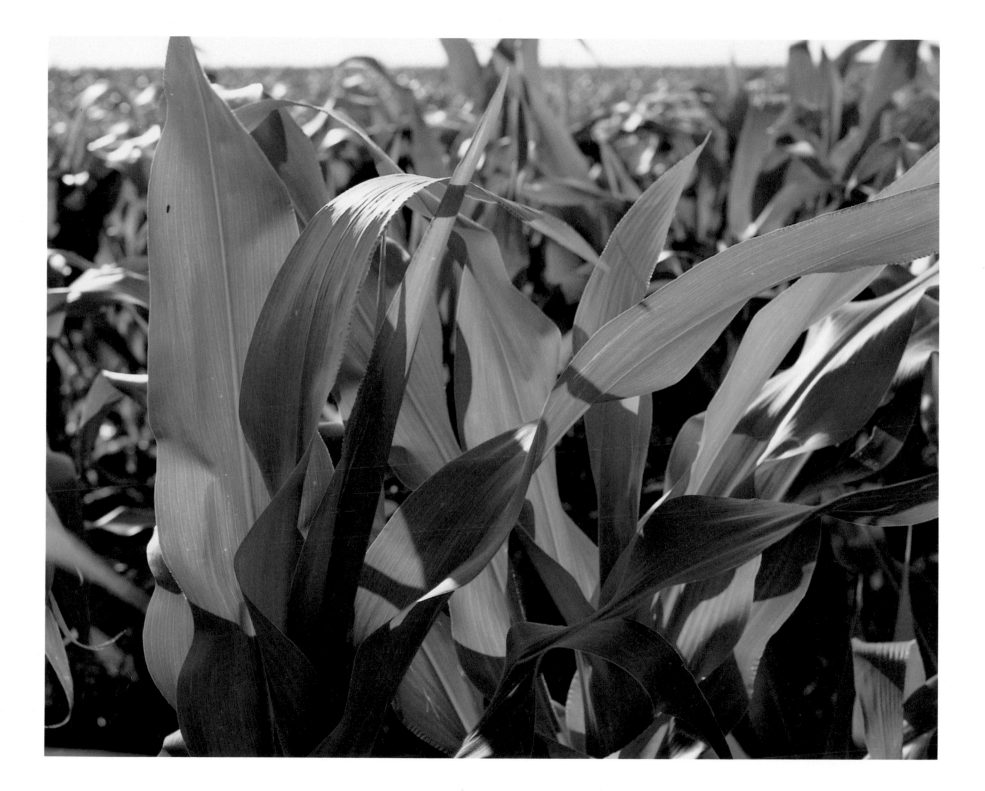

Corn

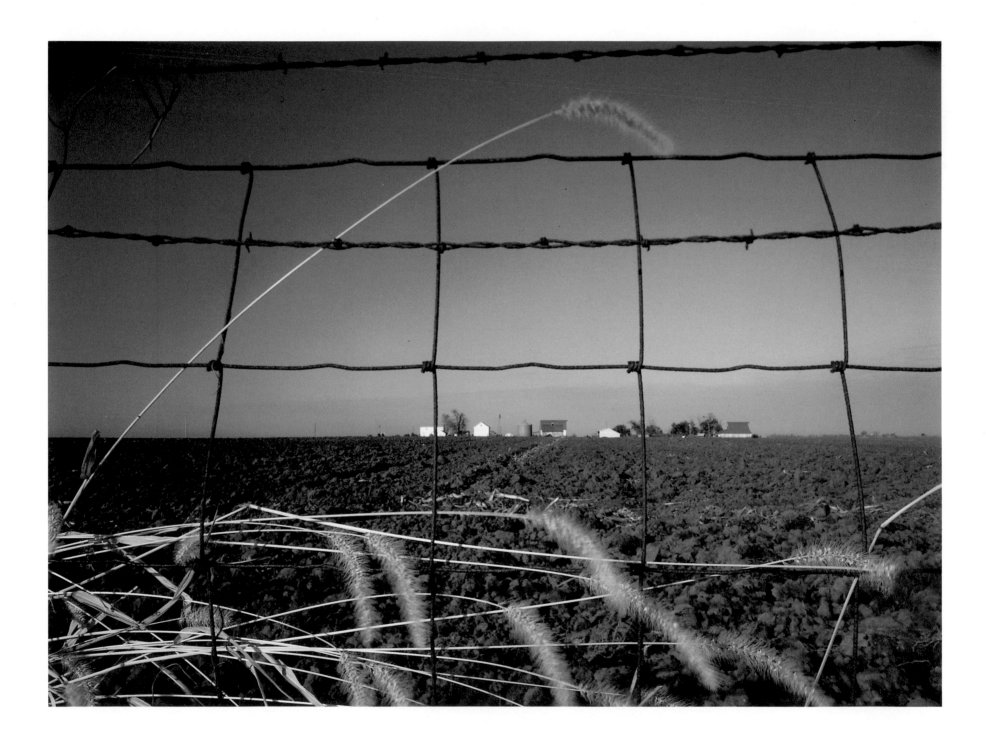

Staley Farm

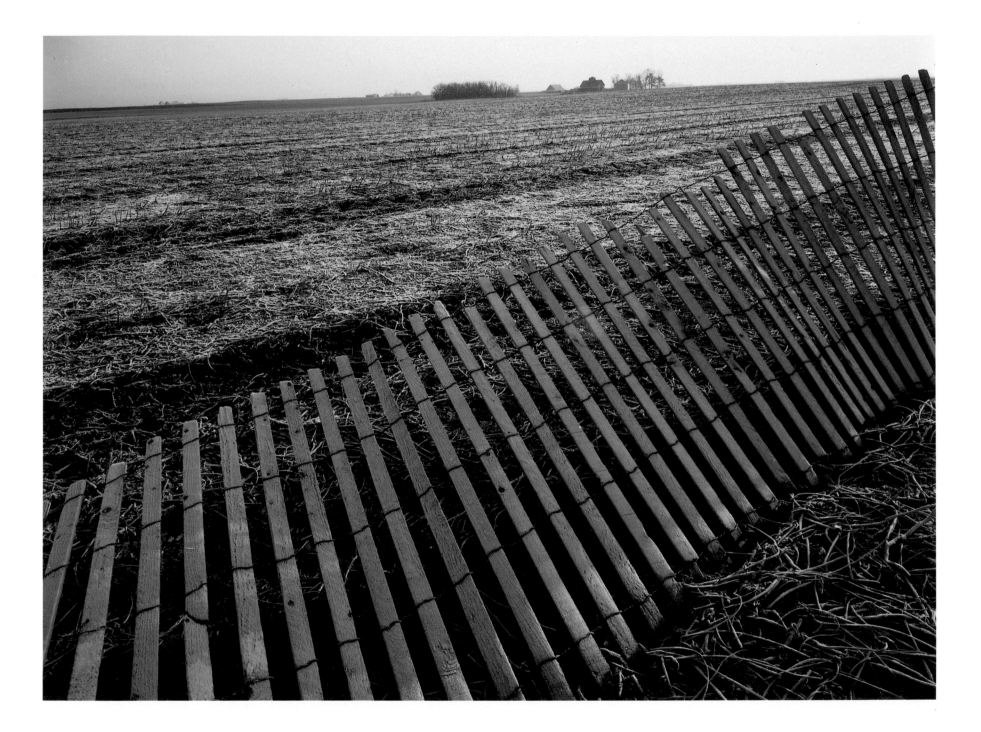

Awaiting Spring

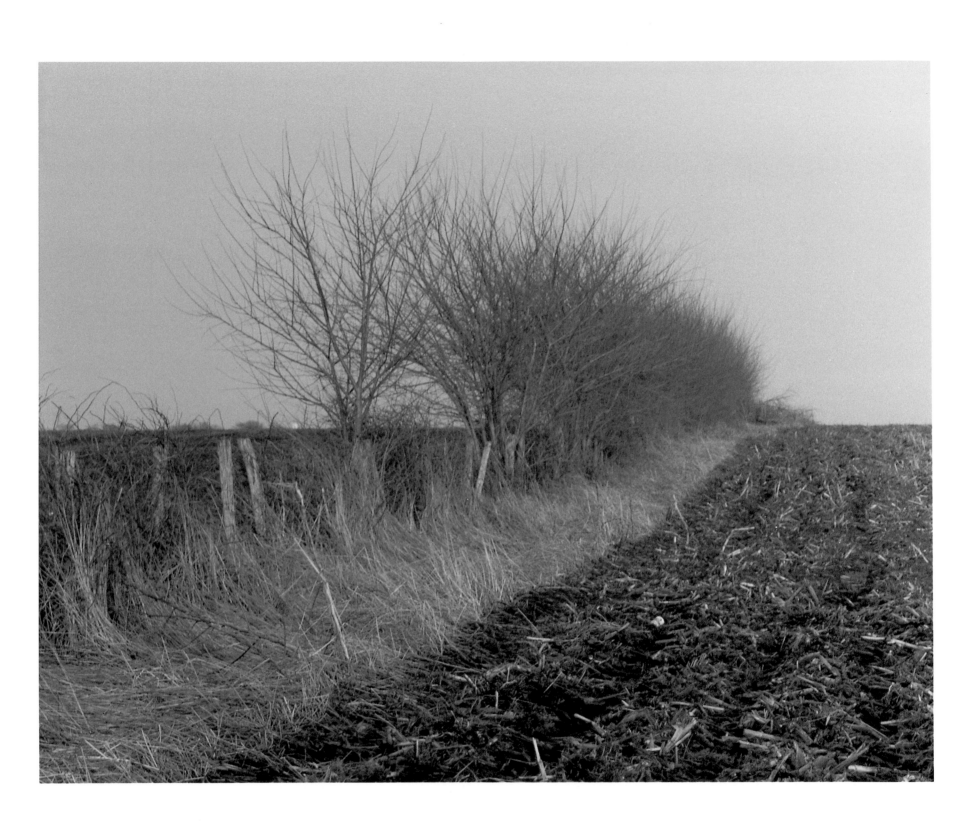

Hedgerow

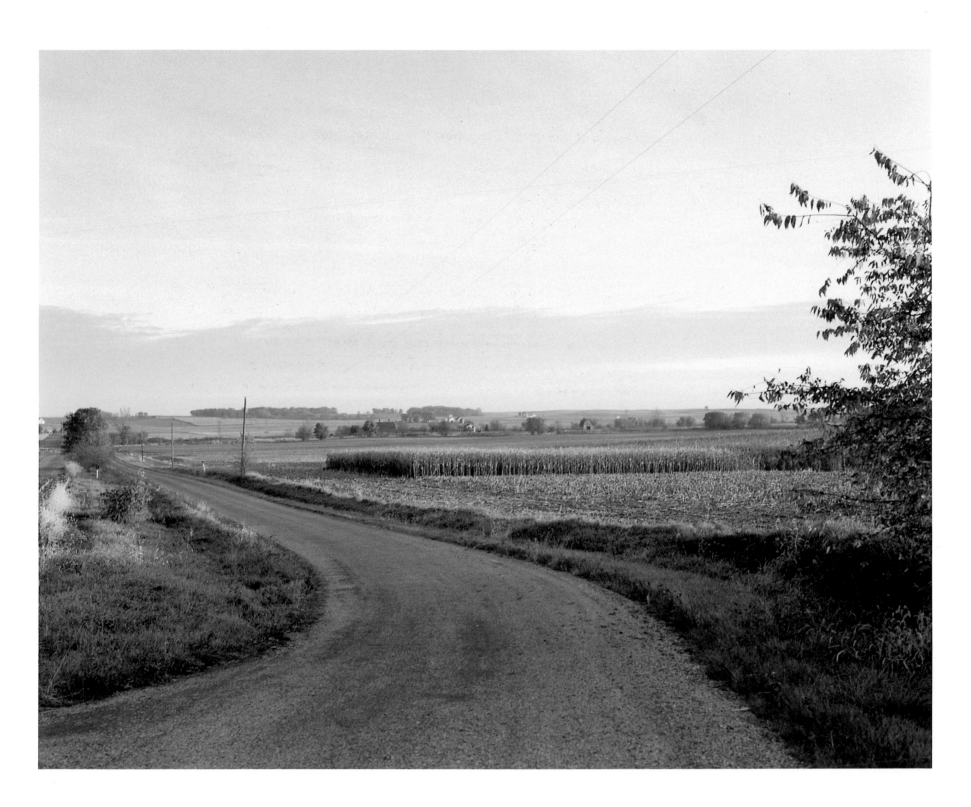

Last Stand

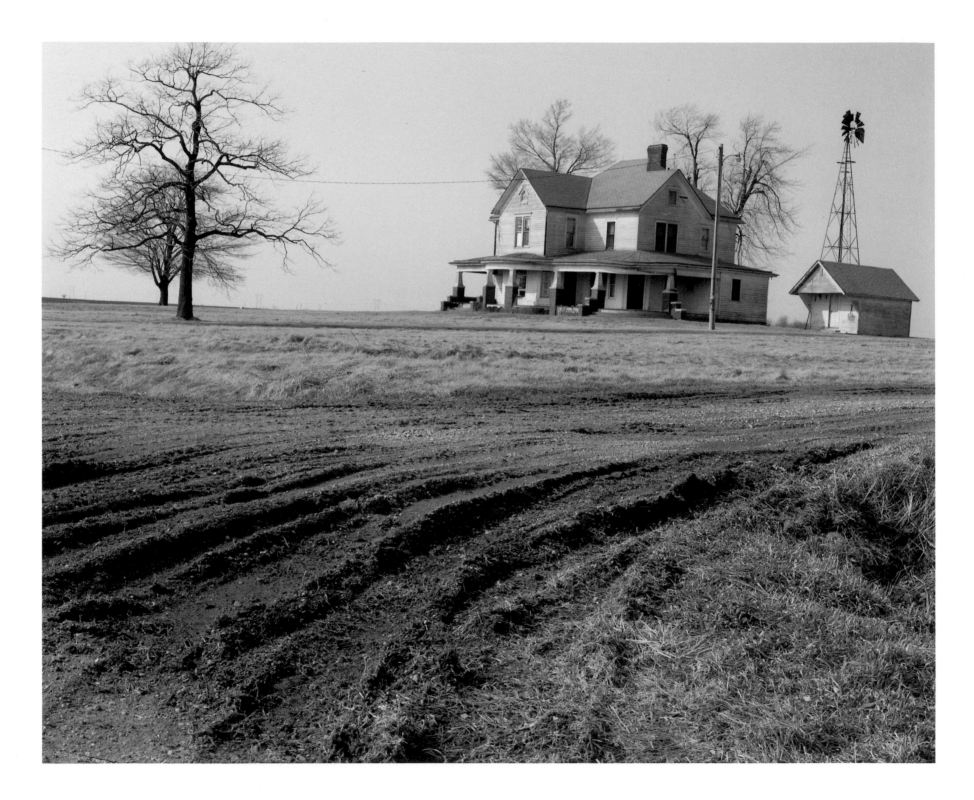

Field Crest

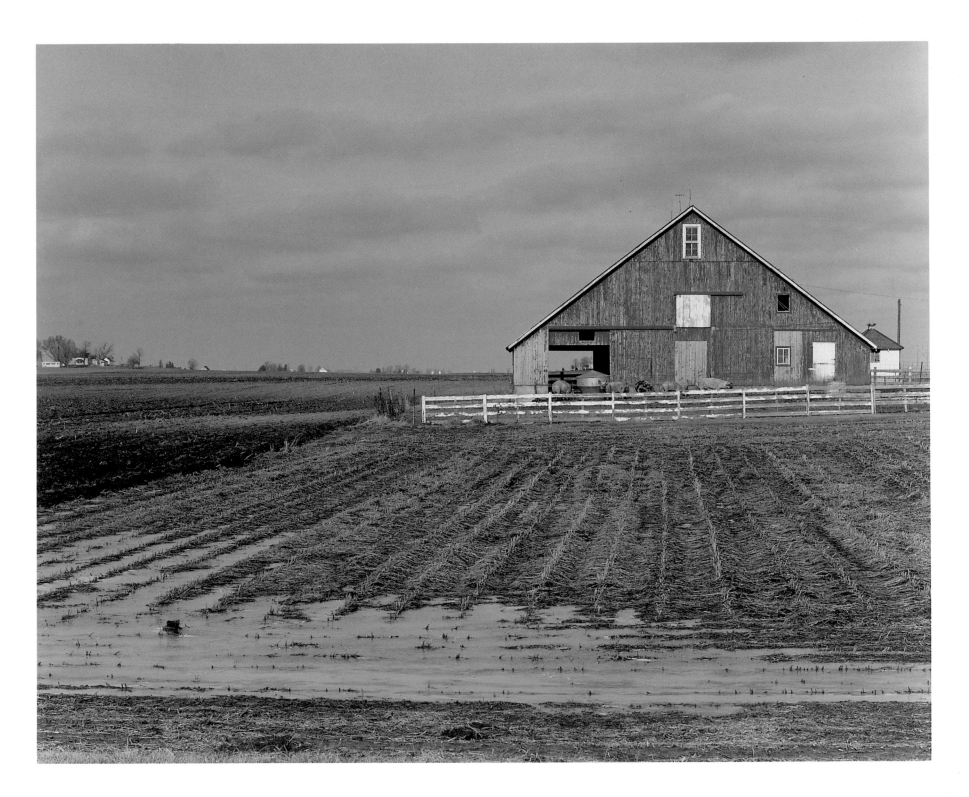

Rustic Country

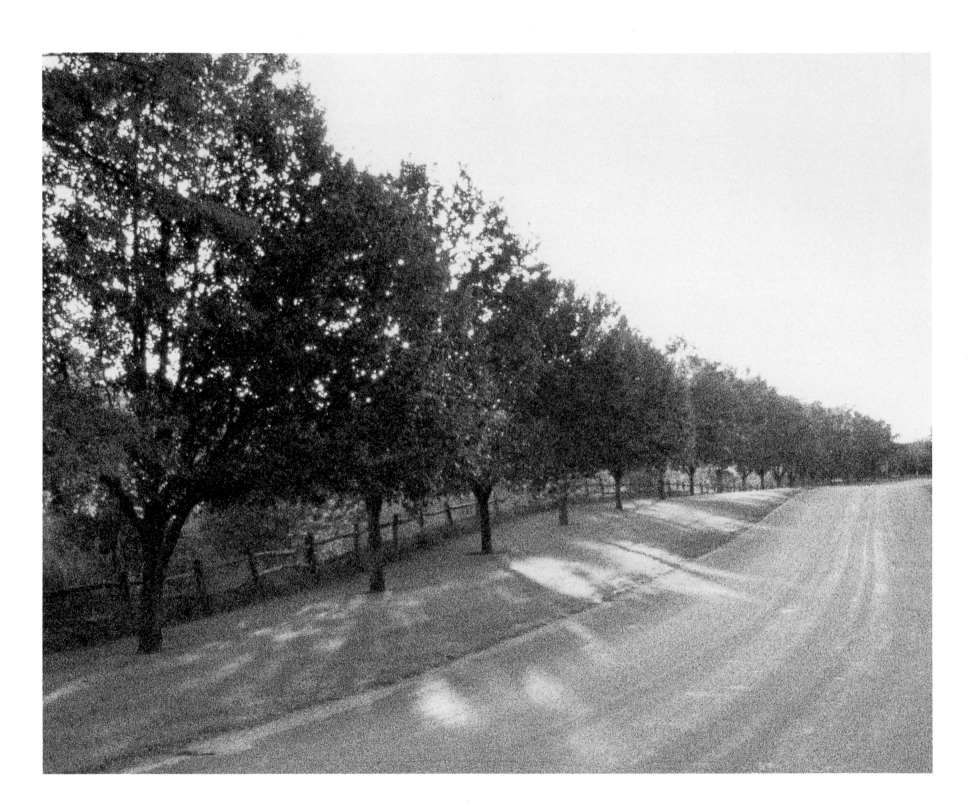

Evening Patterns

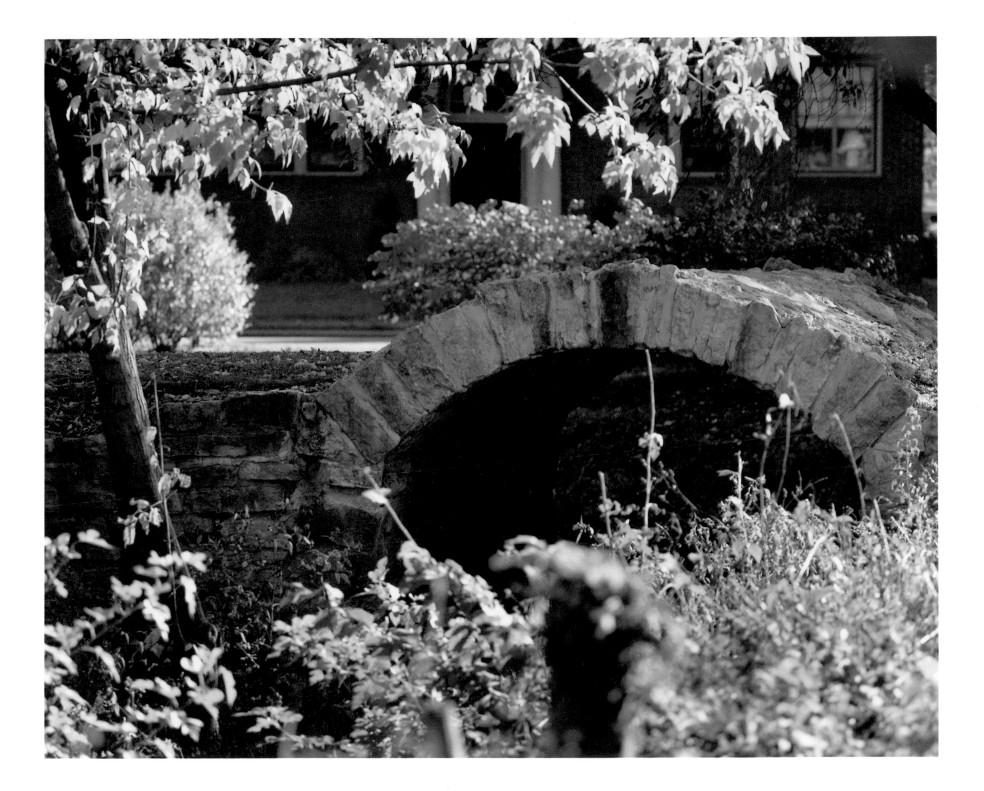

Stone Arch Bridge

Dog Day Afternoon

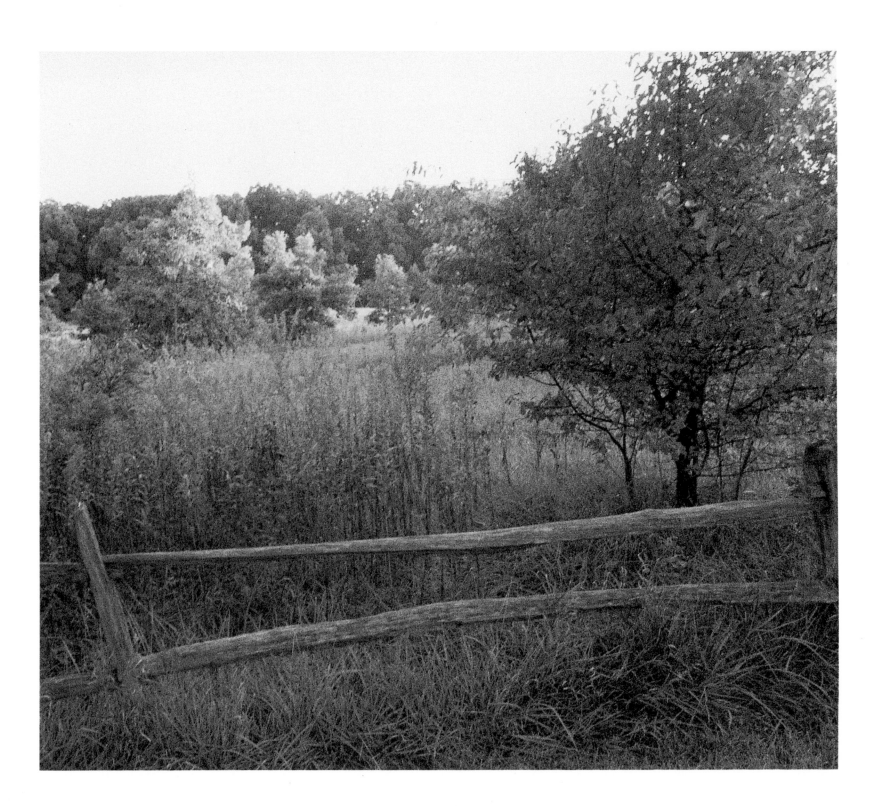

Autumn Meadow

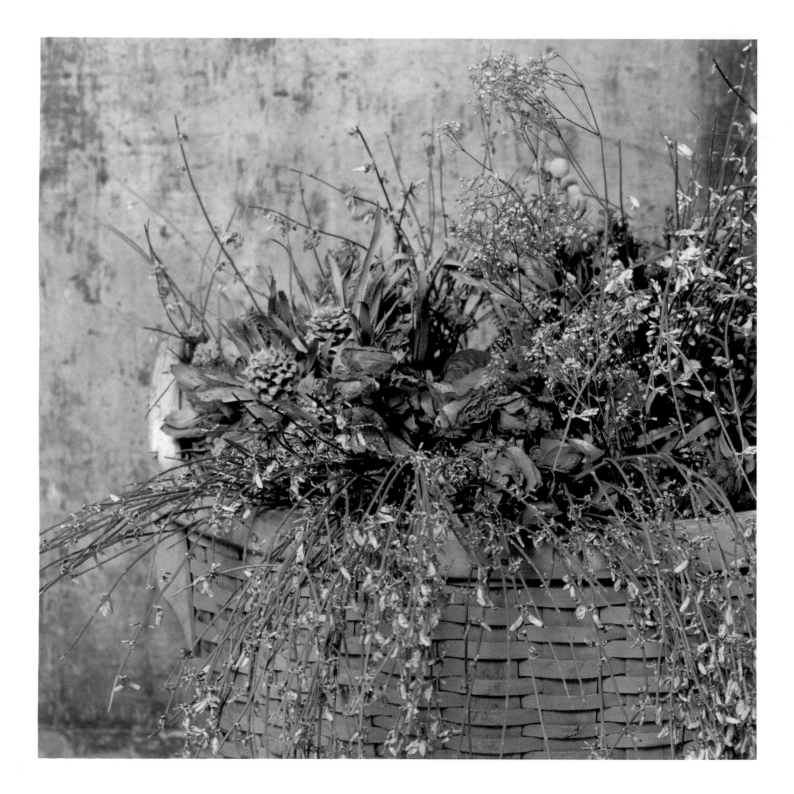

Flower Basket

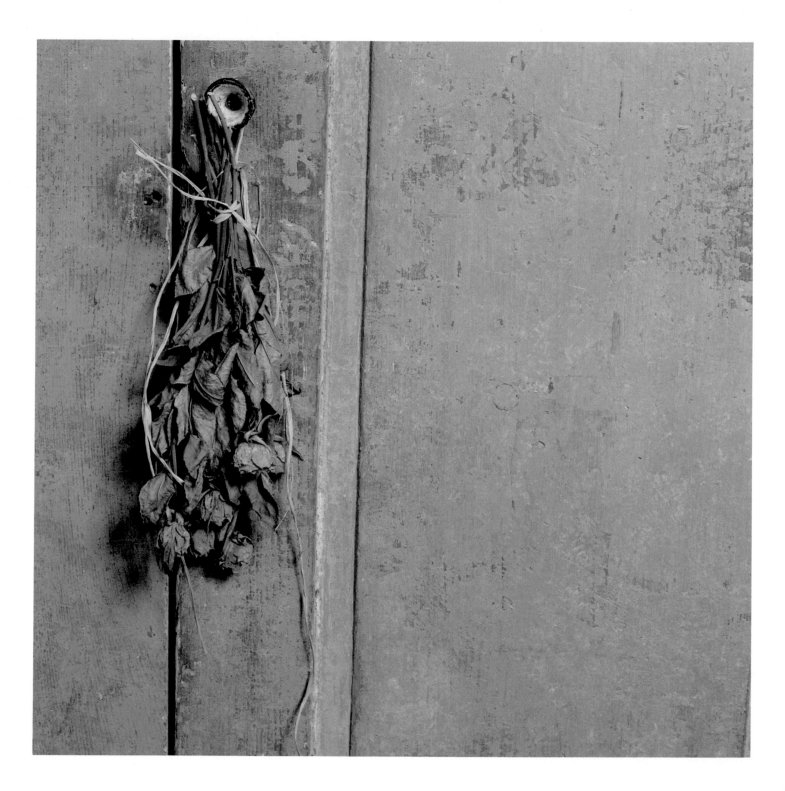

Cupboard Door

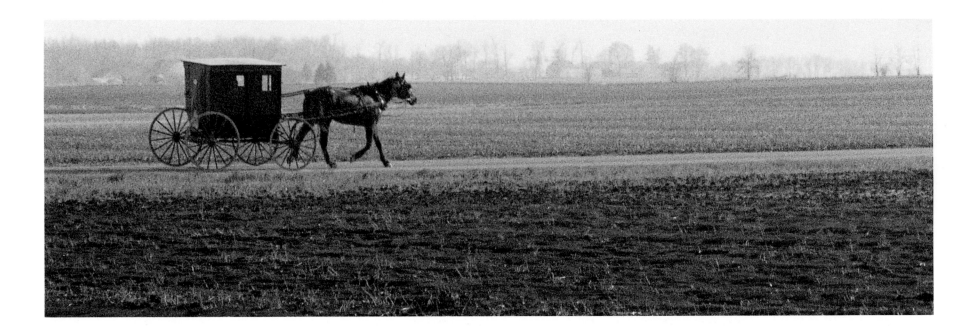

Amish Traveler

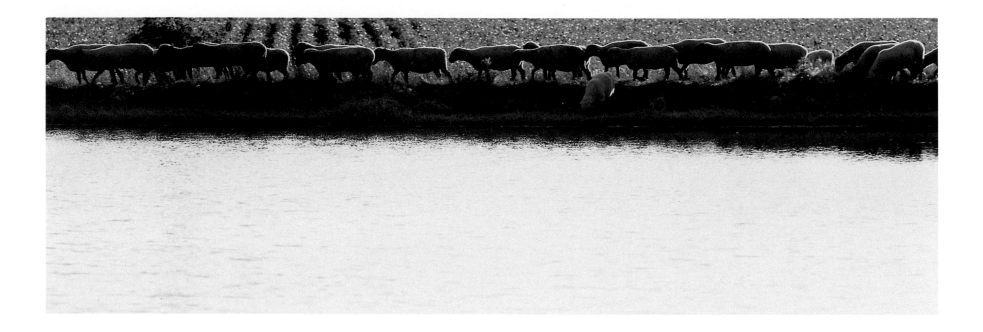

Sheep

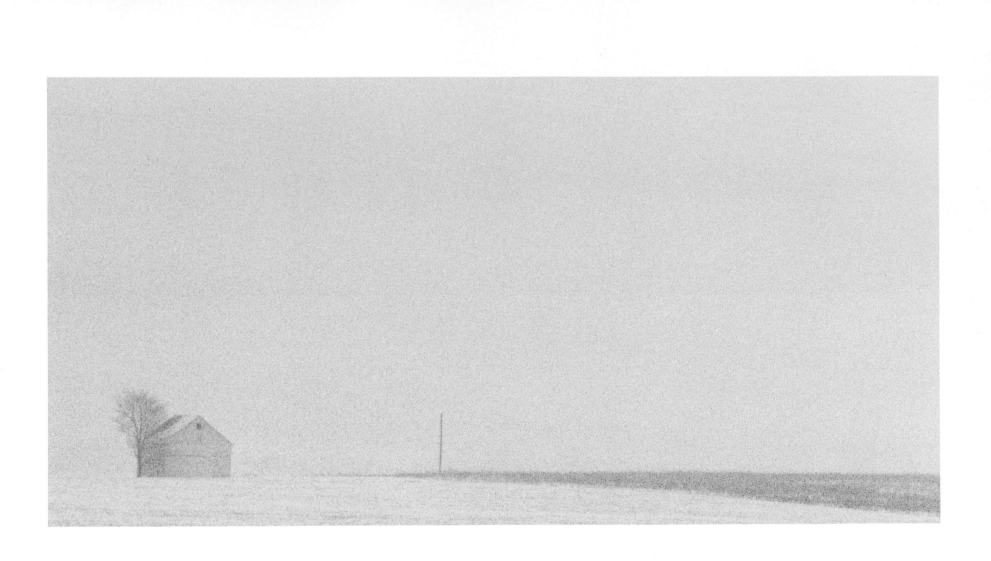

Refuge

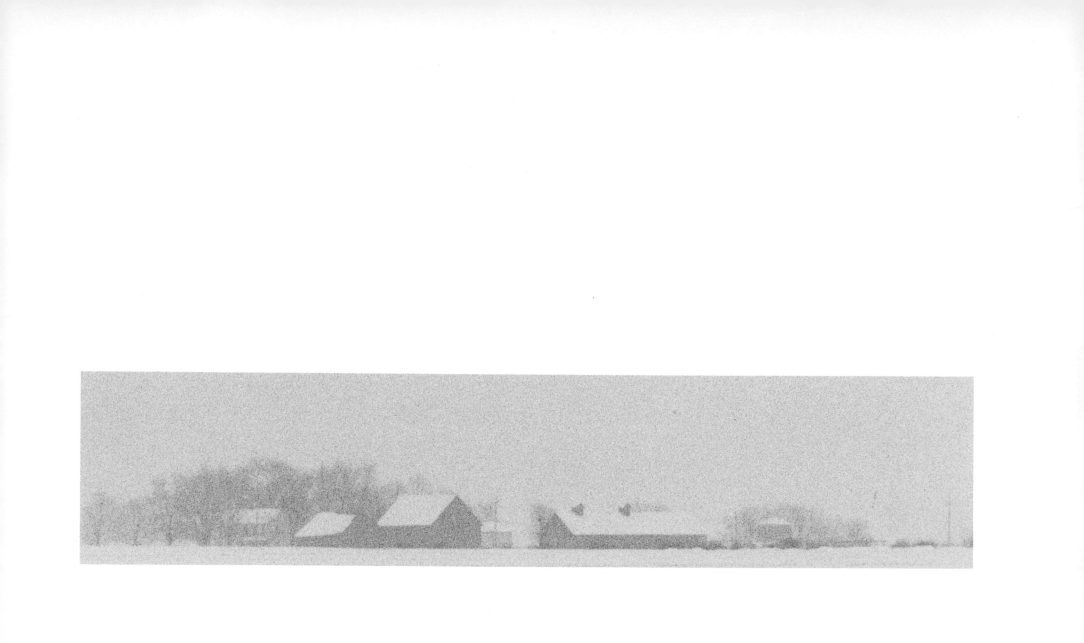

Silent Snow

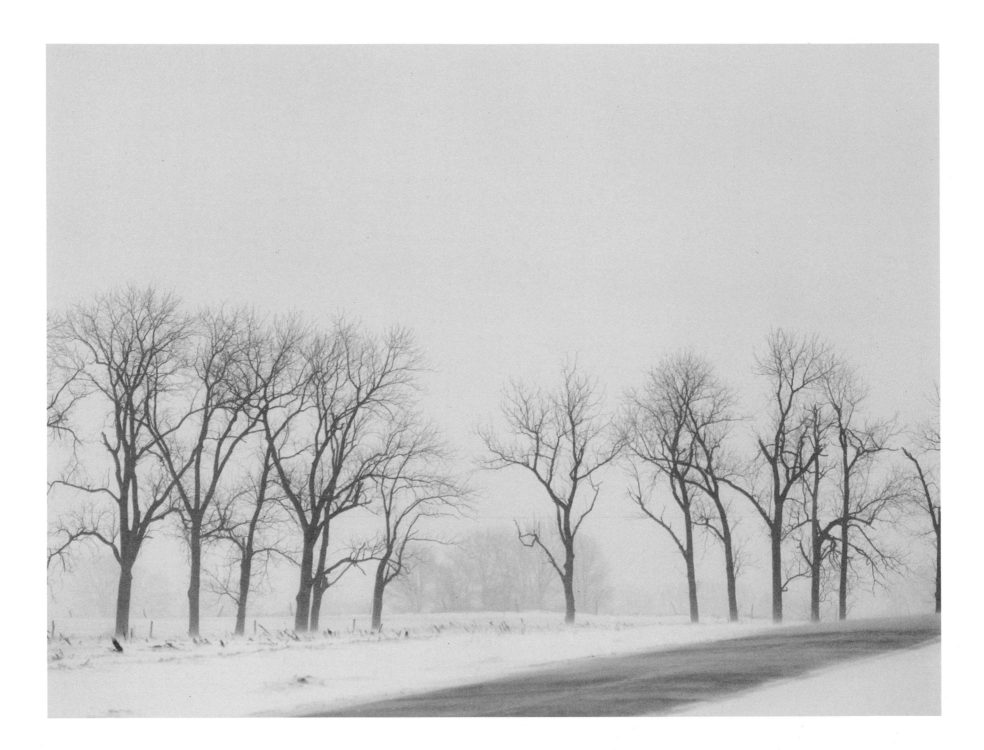

Barren

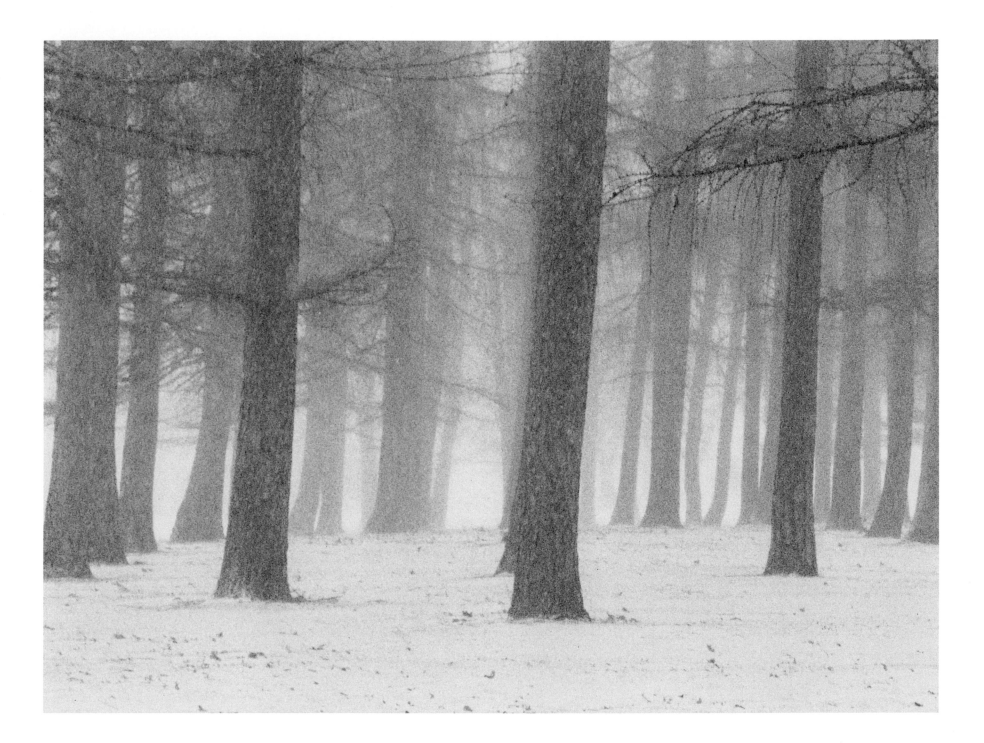

Winter Grove

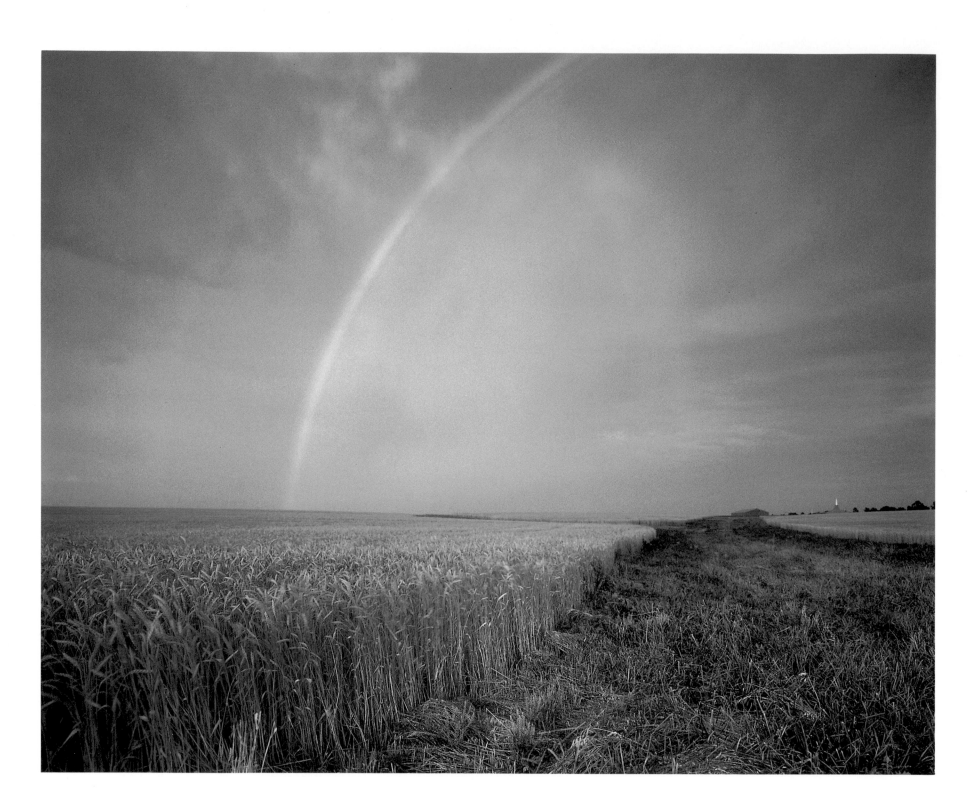

Under the Rainbow

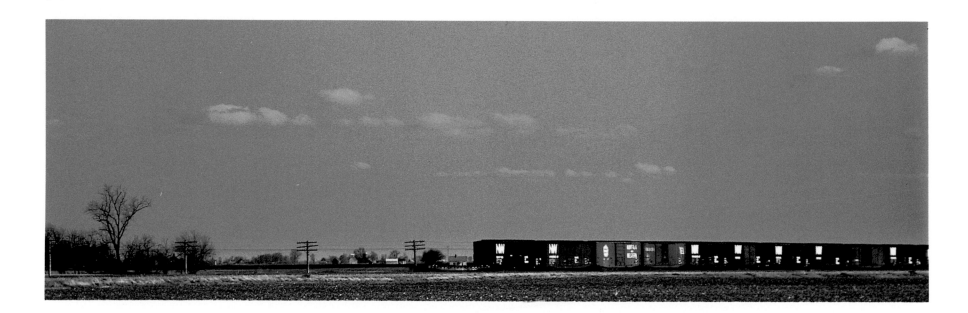

Through the Fields

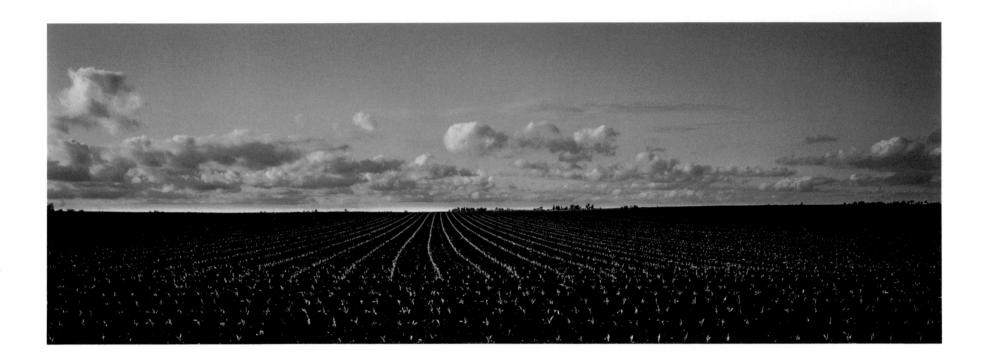

Early Corn

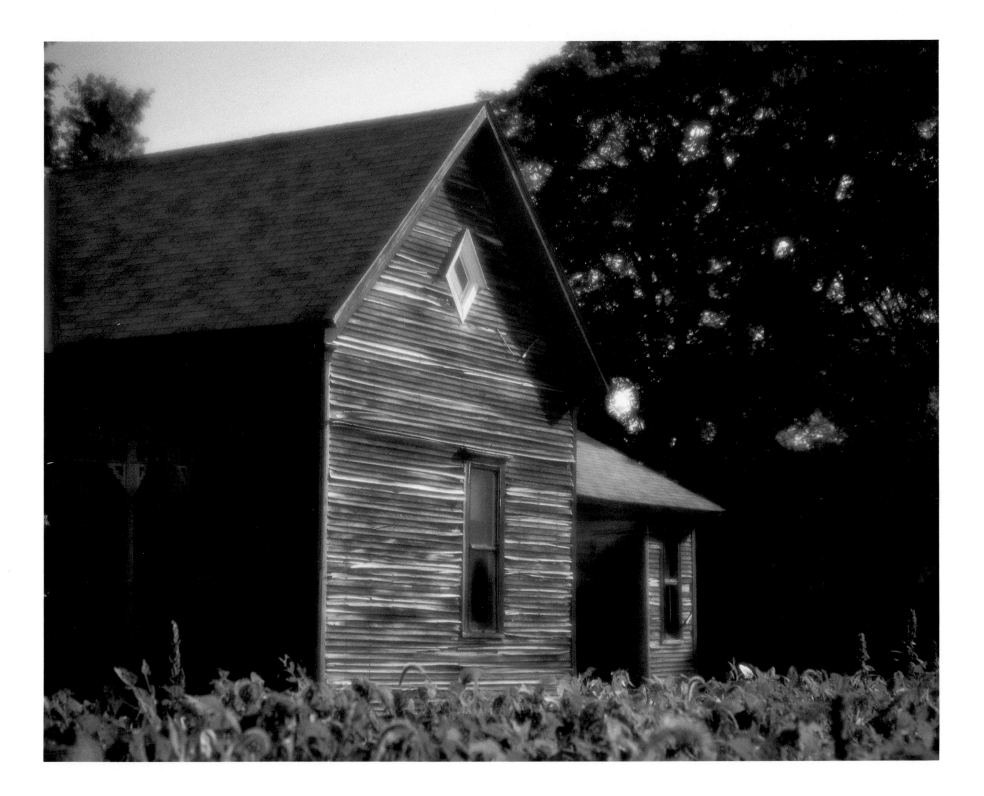

Prairie Cabin

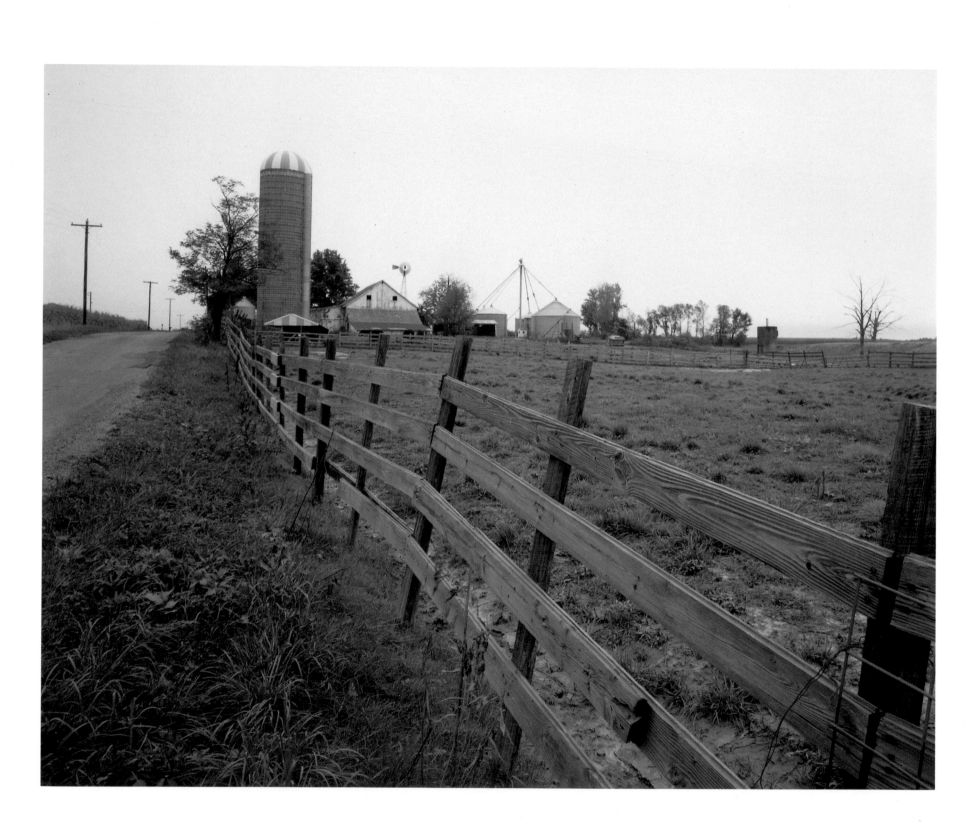

Rockville

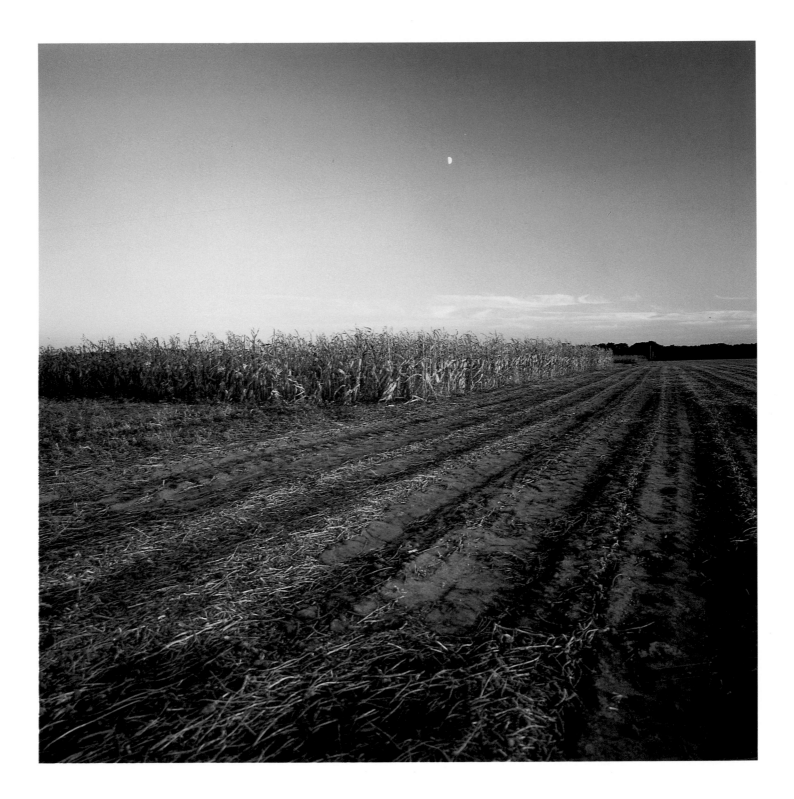

Season's End

85

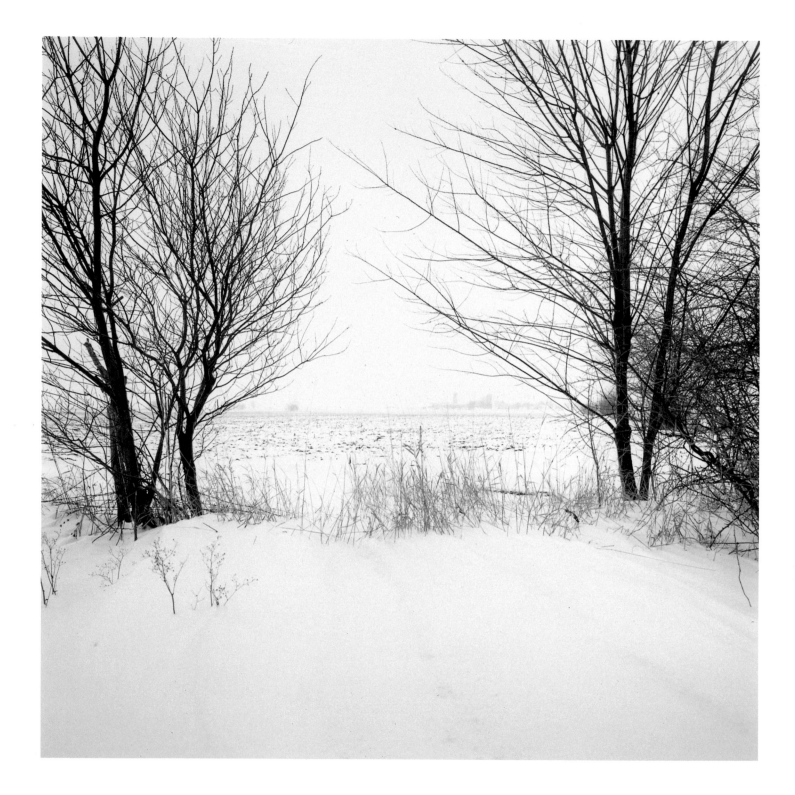

Winter Symmetry

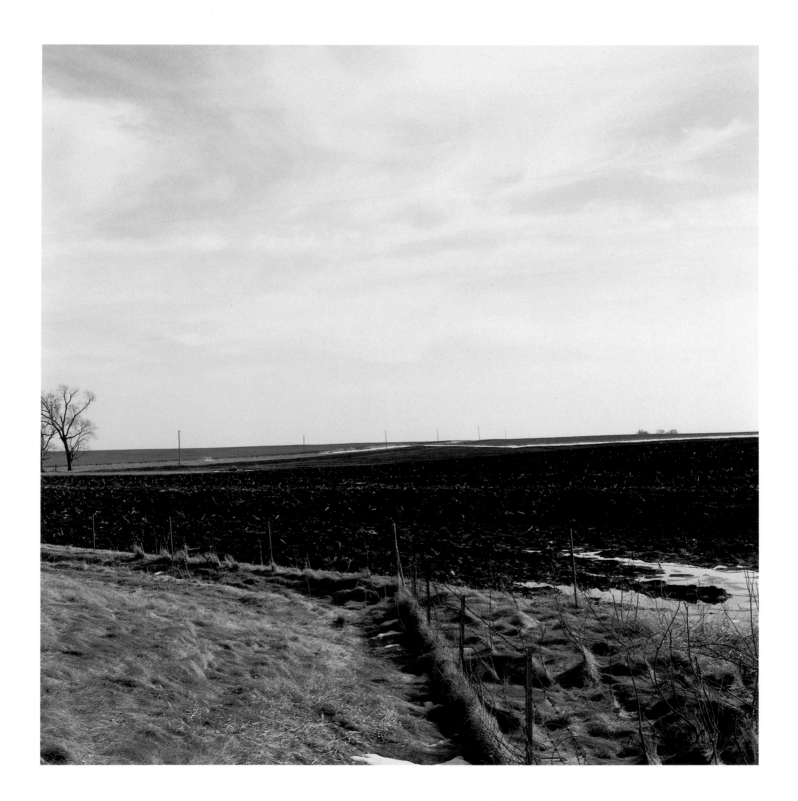

Between Towns

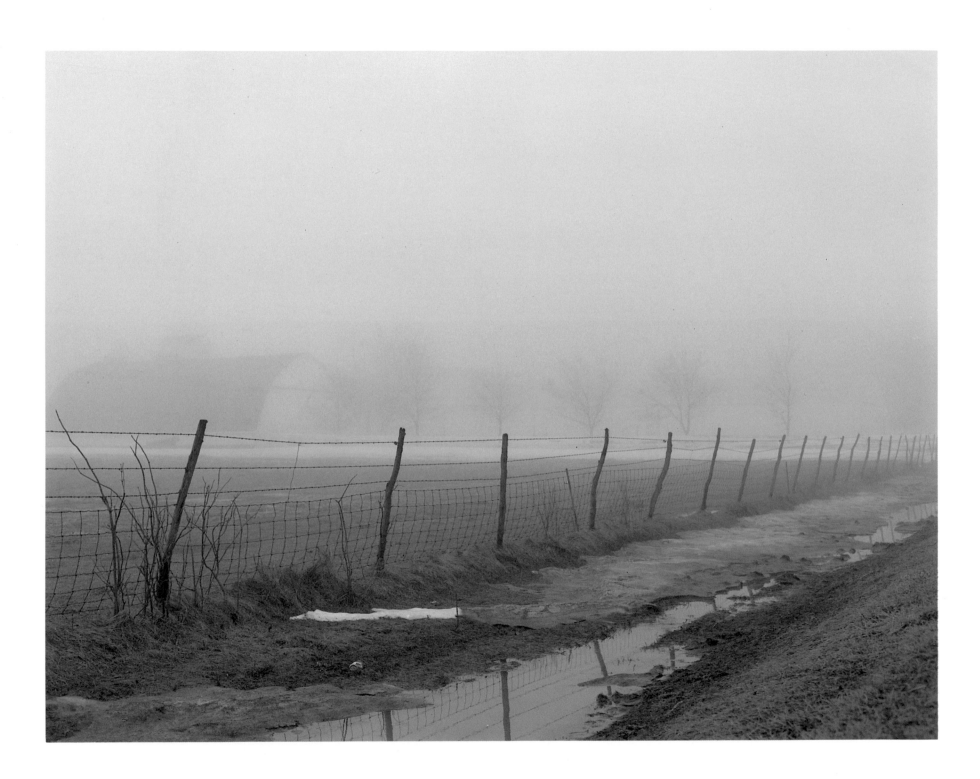

Springtime in Mahomet

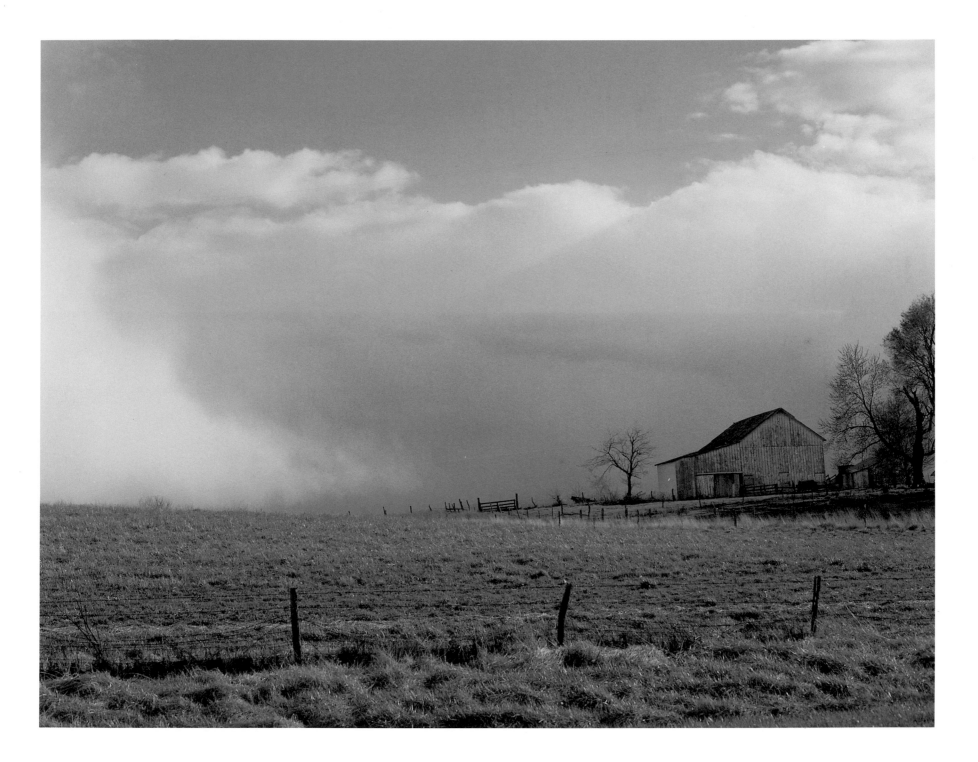

Early Spring

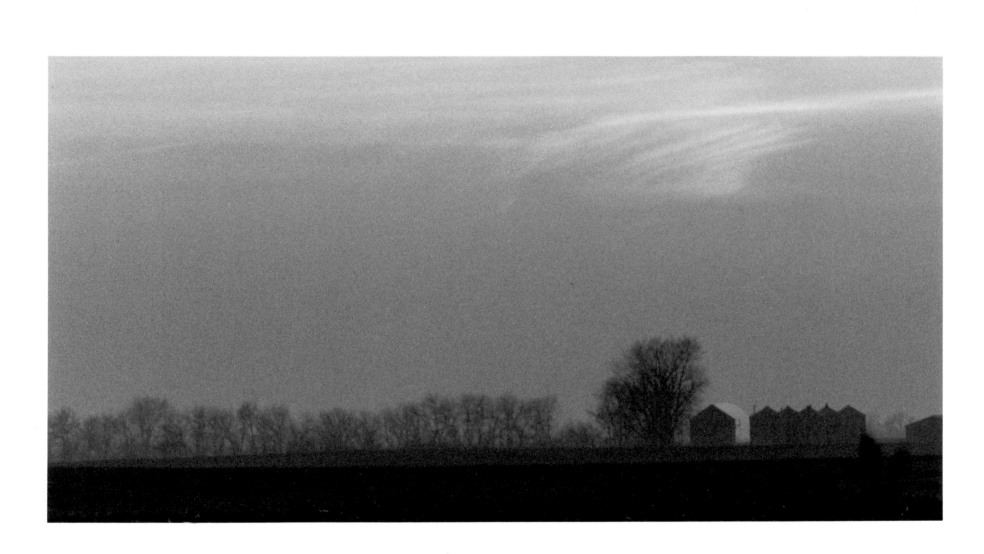

Dawn

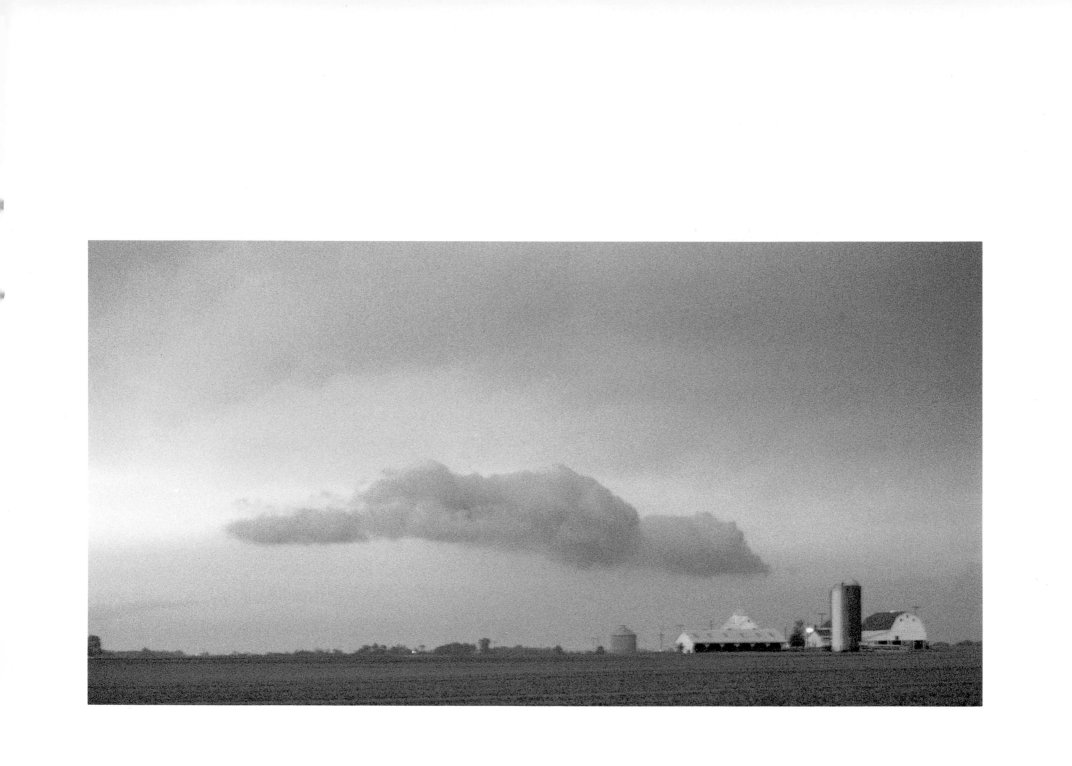

Silver Lining

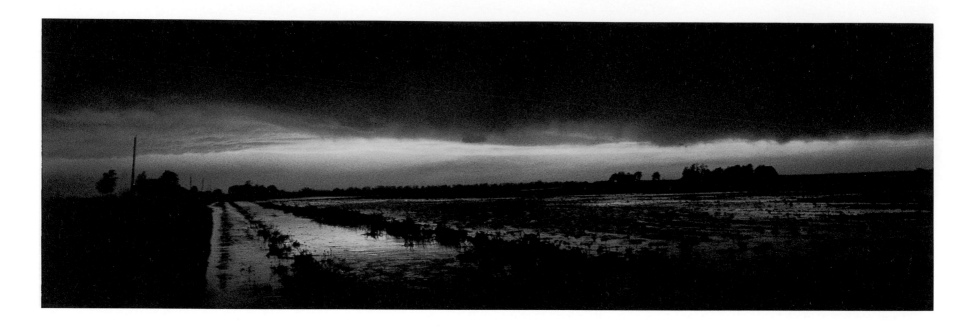

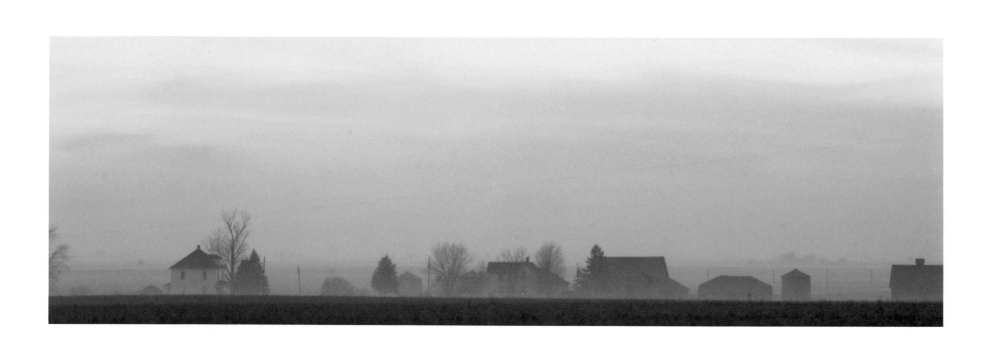

Midwest Horizon

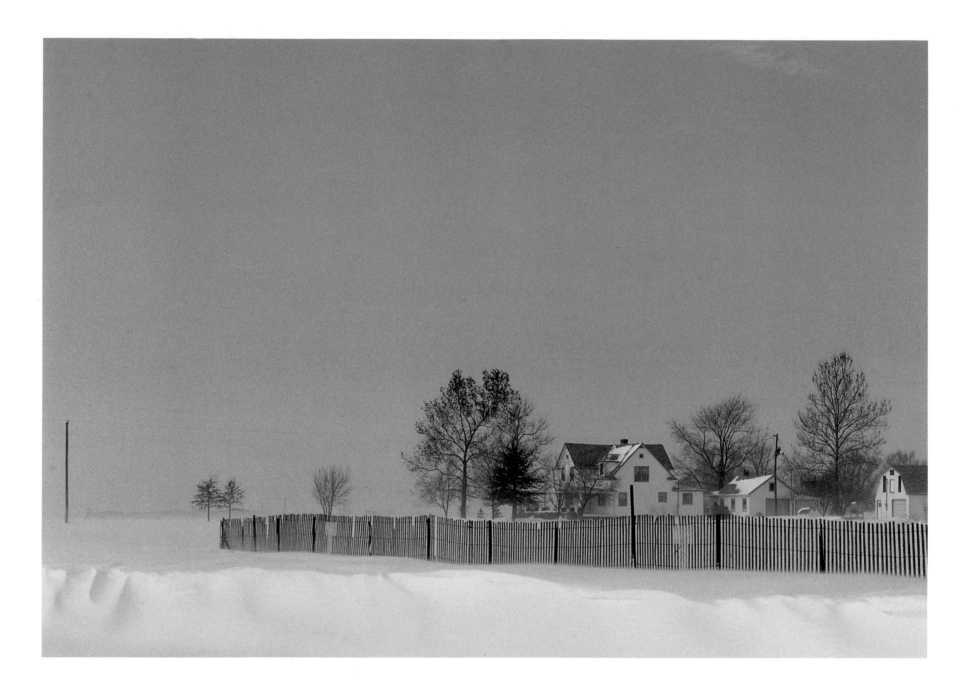

From the North

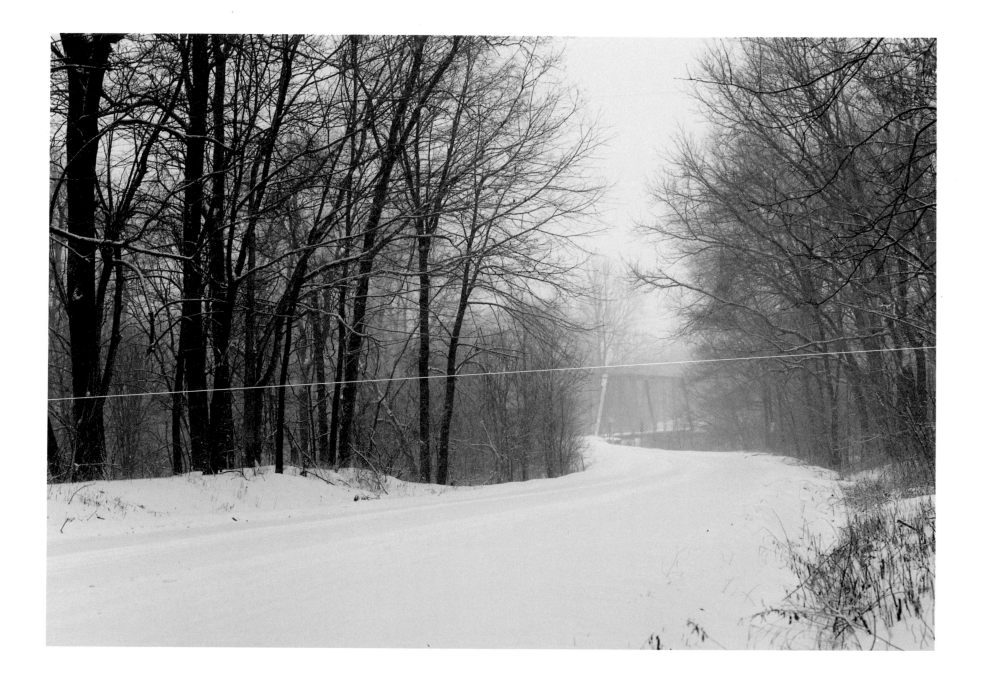

Through the Woods

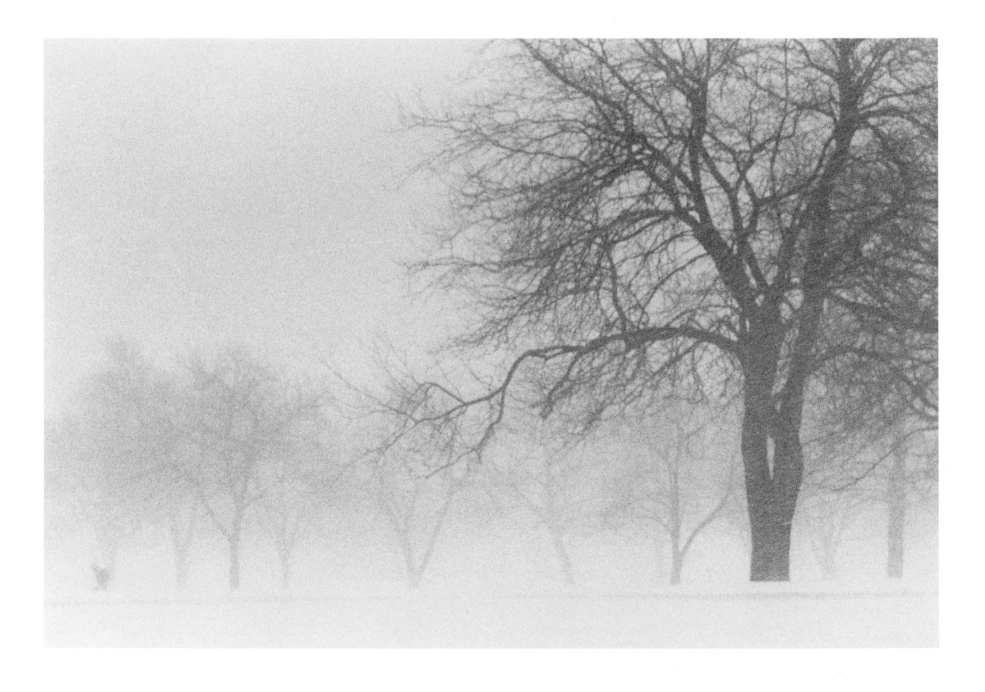

Quadrangle

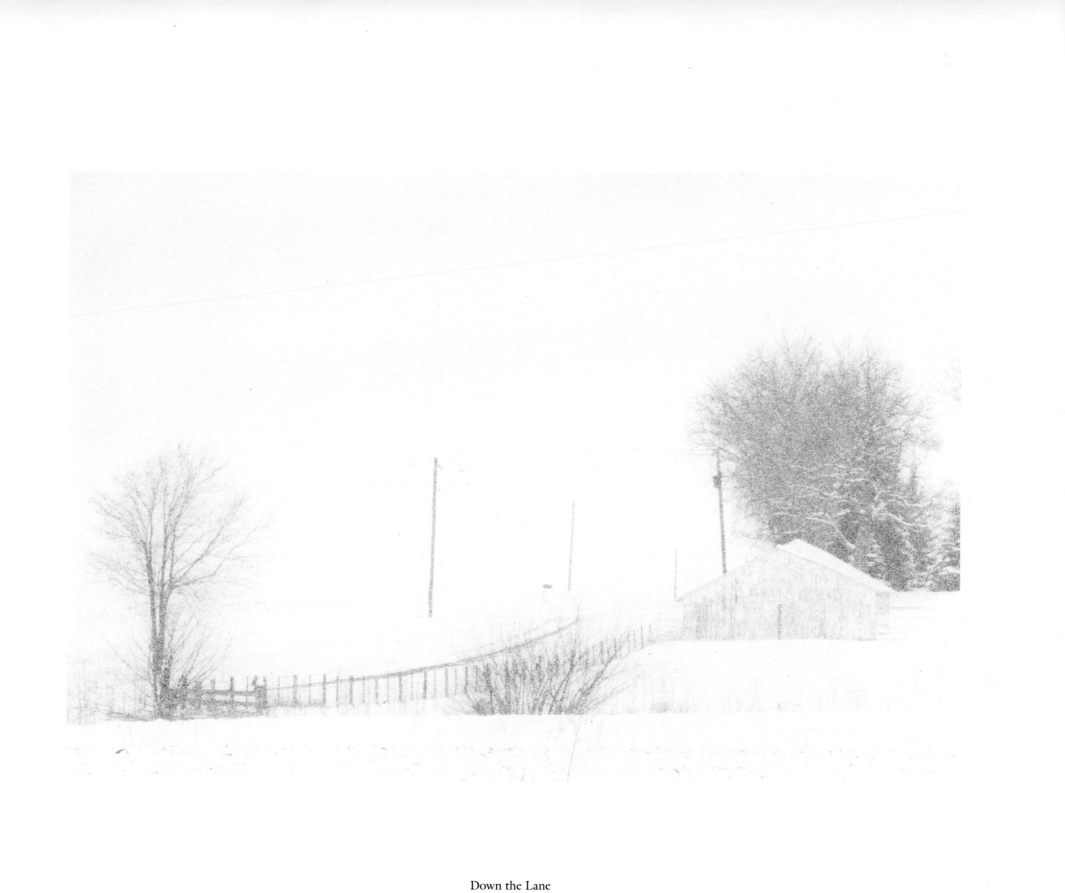

Down the Lane

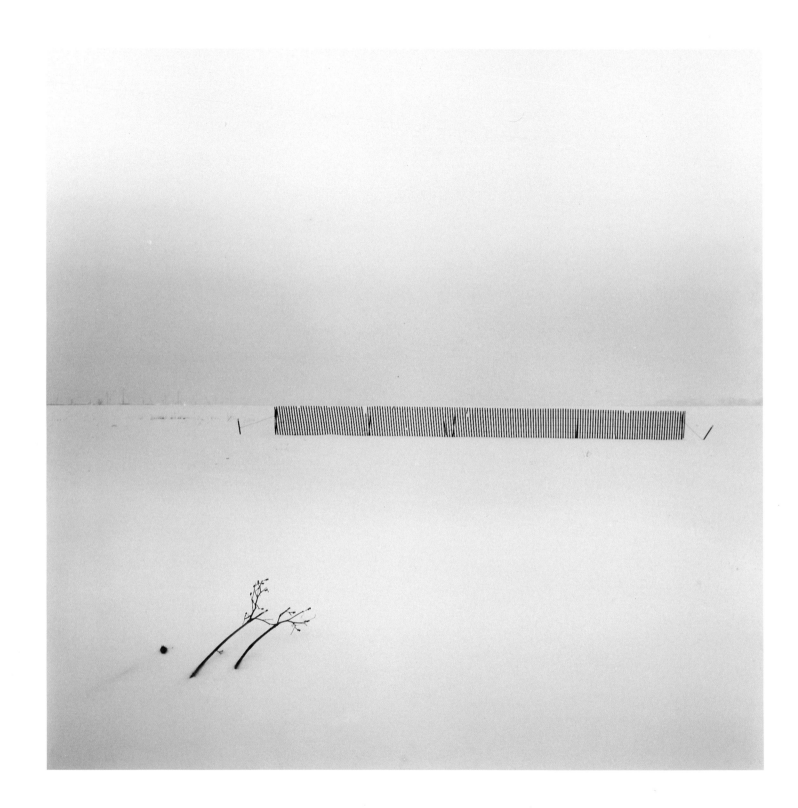

Snow Fence

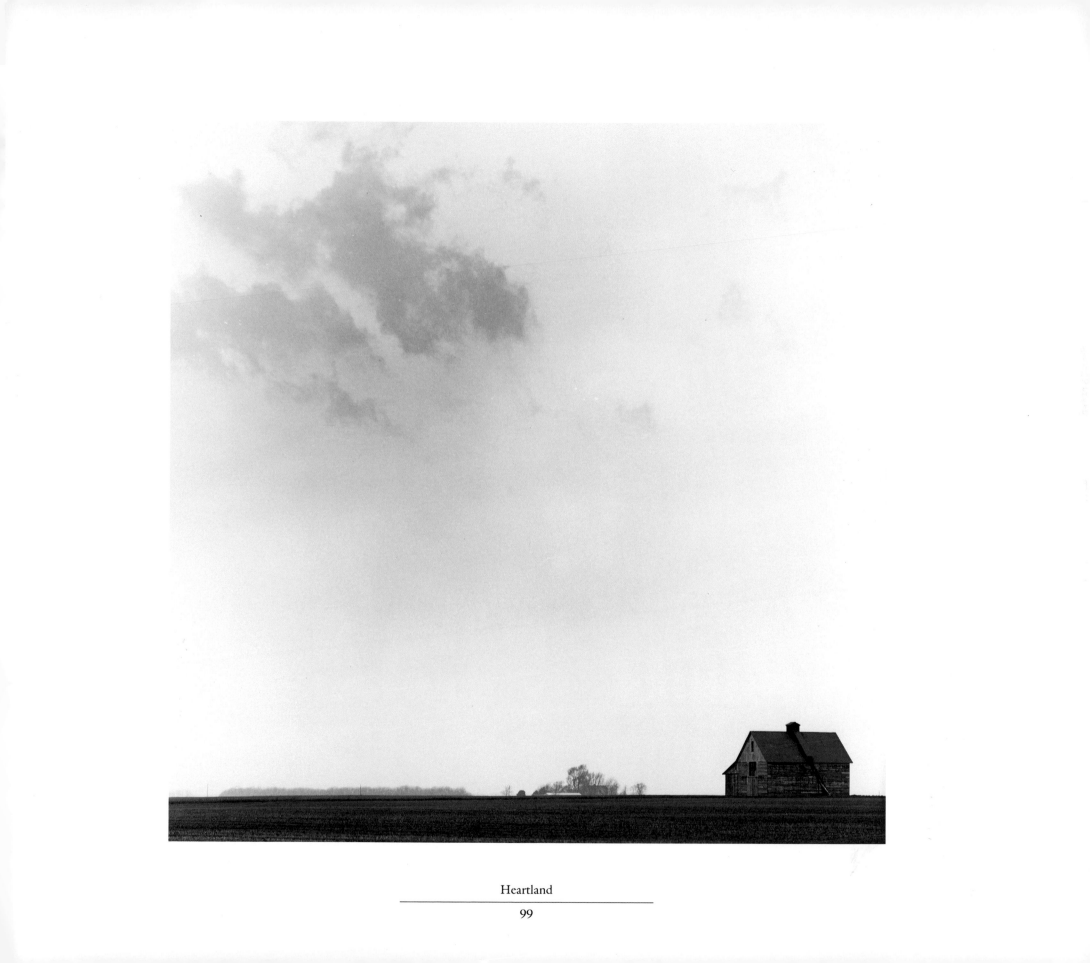

Heartland

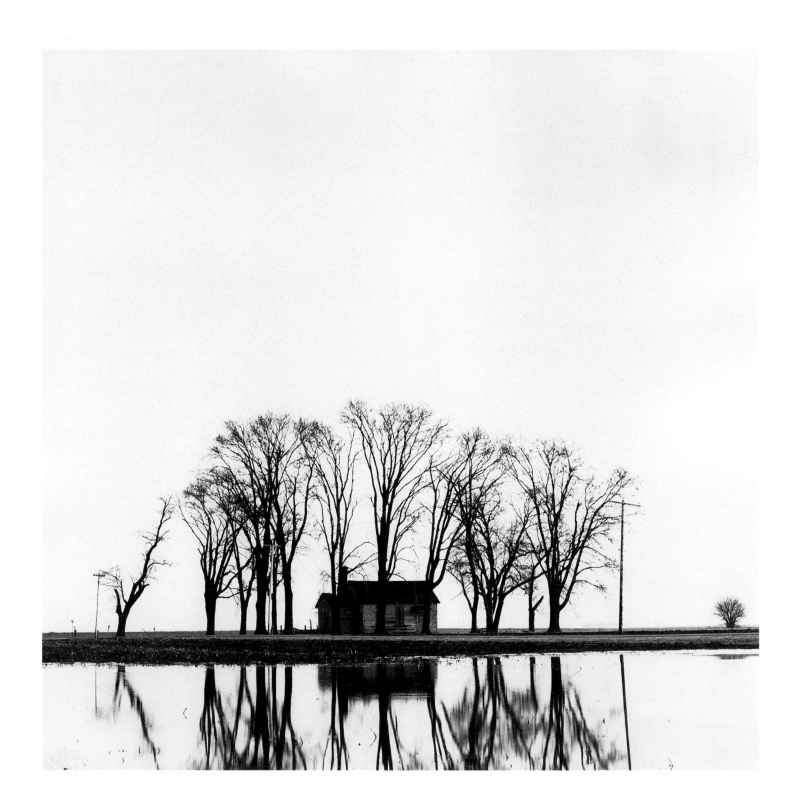

Reflections

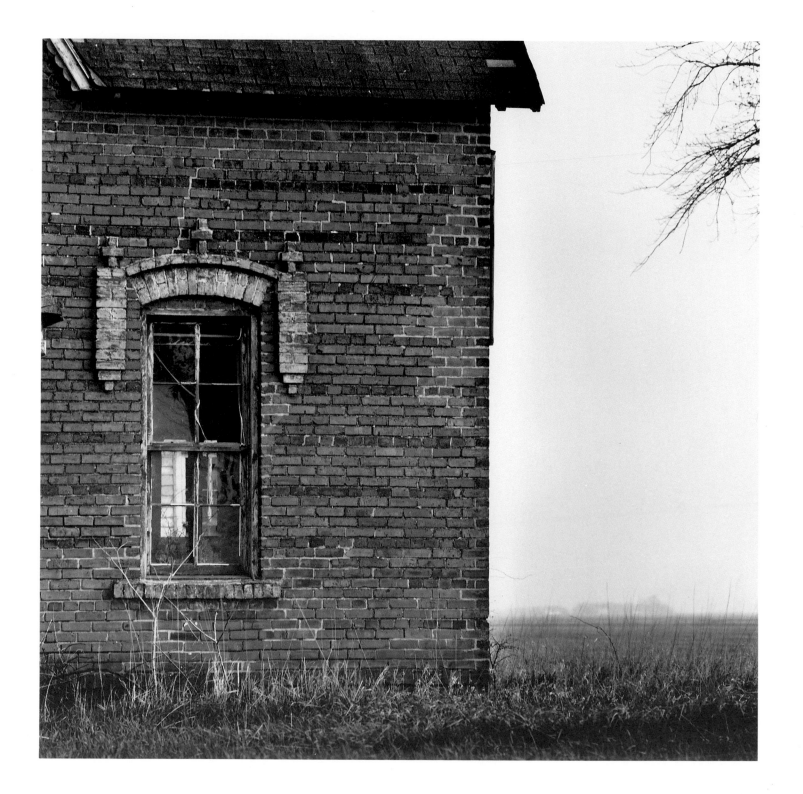

Homestead

1. *Gordon Rainbow*. Late afternoon, spring 1983, east on Curtis Road in Urbana.

2. *Midseason Tempest*. Mid-afternoon, summer 1986, south of Bondville, looking north.

3. *Oasis*. Sunrise, autumn 1982, Rantoul exit on I-57.

4. *Prairie House*. Morning, winter 1982, west of Champaign.

5. *Countryside*. Evening, autumn 1985, near White Heath.

6. *Backyard Sunrise*. Autumn 1985, Payne Farm near Saybrook.

7. *University and Prospect*. Early morning, autumn 1981, looking west in Champaign.

8. *The Harvest*. Afternoon, autumn 1986, south on Duncan Road near Champaign.

9. *Tornado Watch*. Afternoon, spring 1979, Rte. 45, near Curtis Road.

10. *Bayou*. Morning, spring 1983, south of Urbana.

11. *Bare Trees*. Early morning, autumn 1984, southeast Urbana at Myra Station.

12. *Pole Farm*. Mid-morning, winter 1987, near Monticello.

13. *Blizzard of Oz*. Evening, summer 1984, by the Great River Road.

14. *Windsor Sunset*. Spring 1980, west on Windsor Road at the jog.

15. *Grounded*. Midnight, summer 1984, looking toward Homer.

16. *Twilight*. Winter 1982, south on Philo Road.

17. *Magic Road*. Early evening, summer 1984, by Seymour.

18. *Kirby and Mattis*. Early morning, winter 1980, northwest corner of O'Connor Farm in Champaign.

19. *On the Line*. Mid-morning, summer 1985, O'Connor Farm.

20. *Country Afternoon*. Spring 1984, O'Connor Farm.

21. *Gasoline Alley*. Afternoon, spring 1984, O'Connor Farm.

22. *Windsor Barn*. Evening, autumn 1980, Windsor Road on Yankee Ridge.

23. *Oakwood*. Afternoon, autumn 1980, old Rte. 150.

24. *Royal Farmstead*. Morning, spring 1983, on the back road to Royal.

25. *The Back Way*. Early morning, summer 1986, from Mann's Chapel near Rossville.

26. *River Reflections*. Morning, autumn 1983, the Sangamon River on the Allerton Estate.

27. *Allerton*. Early morning, late summer 1982, at the entrance.

28. *Crossroads*. Evening, summer 1982, where Race Street in Urbana meets Church Street in Savoy.

29. *Parrott Farm*. Late afternoon, summer 1981, the I-74 overpass at Mahomet.

30. *Prairie Grass*. Late morning, spring 1985, where Lincoln Avenue becomes Windsor Road.

31. *Prairie Flowers*. Late morning, spring 1985, south County Road.

32. *Skyscrapers*. Evening, summer 1985, near Rising.

33. *Over the Post*. Early evening, spring 1986, just west of Rising.

34. *Fencerow*. Afternoon, winter 1985, White Heath.

35. *Painted Trees*. Afternoon, winter 1985, White Heath.

36. *Round Barn*. Early morning, spring 1980, South Farms.

37. *Midwest Vista*. Evening, autumn 1986, near Willard Airport.

38. *Heartland Daybreak*. Summer 1985, west on Bradley Avenue.

39. *City Harbor*. Afternoon, autumn 1986, Lake Shore Drive.

40. *Hill Street Light*. Late at night, autumn 1983, west Champaign.

41. *Midnight Oasis*. Winter 1984, southeast Urbana at the Philo Road curves.

42. *Stop Moon Crossing*. Summer 1982, south of Gibson City.

43. *Sunset House*. Summer 1981, near Rtes. 47 and 150.

44. *Hunter's Moon Rising*. Autumn 1986, west on Kirby Avenue.

45. *Compass Tree*. Early morning, winter 1982, at University and Prospect.

46. *On the Heights*. Late afternoon, autumn 1986, McLean–Ford county line.

47. *County Line Road*. Late afternoon, autumn 1986, McLean–Ford county line.

48. *Blizzard, Rte. 45*. Afternoon, winter 1980, on the other side of Airport Road in Savoy.

49. *Staley Blizzard*. Afternoon, winter 1981, south Staley Road between Curtis and Windsor roads.

50. *Winter Morning I*. 1986. Piatt County.

51. *Winter Morning II*. 1986. Piatt County.

52. *Winter Road*. Afternoon, 1981, western Champaign County.

53. *Meese Farm*. Afternoon, winter 1981, western Champaign County.

54. *Loner*. Early evening, spring 1980, Rte. 45 near Sadorus Road.

55. *Monticello Rise*. Evening, autumn 1983, just off the Monticello Slab.

56. *South Farms*. Morning, summer 1986, University of Illinois campus.

57. *Romantic Retreat*. Afternoon, summer 1986, a camp in Piatt County.

58. *Osage*. Evening, winter 1980, two miles west of the Staley Road jog.

59. *Bare Field under Harvest Moon*. Autumn 1986, between White Heath and Monticello.

60. *Soybeans*. Afternoon, summer 1984, in the country.

61. *Corn*. Afternoon, summer 1984, in the country.

62. *Staley Farm*. Evening, winter 1981, at the Staley Road jog.

63. *Awaiting Spring*. Morning, winter 1982, Rantoul.

64. *Hedgerow*. Afternoon, autumn 1985, a few miles south of Rte. 150.

65. *Last Stand*. Morning, autumn 1985, Payne Farm near Saybrook.

66. *Field Crest*. Afternoon, spring 1983, near Maroa, on the way to Grandma's house.

67. *Rustic County*. Afternoon, spring 1983, Rte. 10 near the Lodge curve.

68. *Evening Patterns.* Autumn 1986, Lake of the Woods.

69. *Stone Arch Bridge.* Late afternoon, autumn 1985, between Urbana and West Urbana.

70. *Dog Day Afternoon.* Spring 1986, Main Street in Arthur.

71. *Autumn Meadow.* Afternoon, 1986, Lake of the Woods.

72. *Flower Basket.* Evening, spring 1985, still life.

73. *Cupboard Door.* Evening, spring 1985, still life.

74. *Amish Traveler.* Afternoon, spring 1984, south of Arthur.

75. *Sheep.* Evening, summer 1985, between the Illinois Central and South First Street.

76. *Refuge.* Afternoon, winter 1987, Piatt County.

77. *Silent Snow.* Morning, winter 1987, Piatt County.

78. *Barren.* Morning, winter 1985, Dewey-Fisher Road.

79. *Winter Grove.* Morning, 1984, on Lincoln Avenue.

80. *Under the Rainbow.* Evening, summer 1984, near the ridge on south Duncan Road.

81. *Through the Fields.* Afternoon, spring 1984, LeRoy.

82. *Early Corn.* Morning, spring 1985, off the Dewey-Fisher Road.

83. *Prairie Cabin.* Morning, summer 1984, outside Shelbyville.

84. *Rockville.* Afternoon, autumn 1983, western Indiana.

85. *Season's End.* Evening, autumn 1986, Piatt County.

86. *Winter Symmetry.* Afternoon, 1985, Vermilion County.

87. *Between Towns.* Evening, spring 1987, I-74 near Downs.

88. *Springtime in Mahomet.* Morning, 1982, Rte. 47 at Herriott's Farm.

89. *Early Spring.* Afternoon, 1985, Taylorville.

90. *Dawn.* Winter 1986, McLean County.

91. *Silver Lining.* Evening, autumn 1986, near Deland.

92. *Post-Meridian.* Spring 1986, west Bradley Avenue.

93. *Midwest Horizon.* Evening, winter 1985, Staley Road near Kirby.

94. *From the North.* Morning, winter 1987, west edge of Bondville.

95. *Through the Woods.* Afternoon, winter 1985, Kickapoo.

96. *Quadrangle.* Afternoon, winter 1983, University of Illinois campus.

97. *Down the Lane.* Afternoon, winter 1987, Ivesdale.

98. *Snow Fence.* Afternoon, winter 1982, looking north from Winfield.

99. *Heartland.* Afternoon, spring 1985, southeast of Tolono.

100. *Reflections.* Early morning, winter 1984, west on Rte. 10.

101. *Homestead.* Evening, spring 1984, Pesotum.

Photo by Wilmer Zehr

Larry Kanfer is a professional photographer with a studio and gallery in Champaign, Illinois. He was born in St. Louis, Missouri, but spent much of his boyhood in the Pacific Northwest. A resident of the Prairie State since 1973, he has a degree in architectural studies from the University of Illinois at Urbana-Champaign. Kanfer has received several awards of excellence for his interpretive landscape photography, which is carried by galleries in the Midwest and on the West Coast.